August 4, 2001

Scott —

 Happy 50th!
 To fond memories with you
on the island and many more!

Best Wishes
 Always,

Gerald & Evan

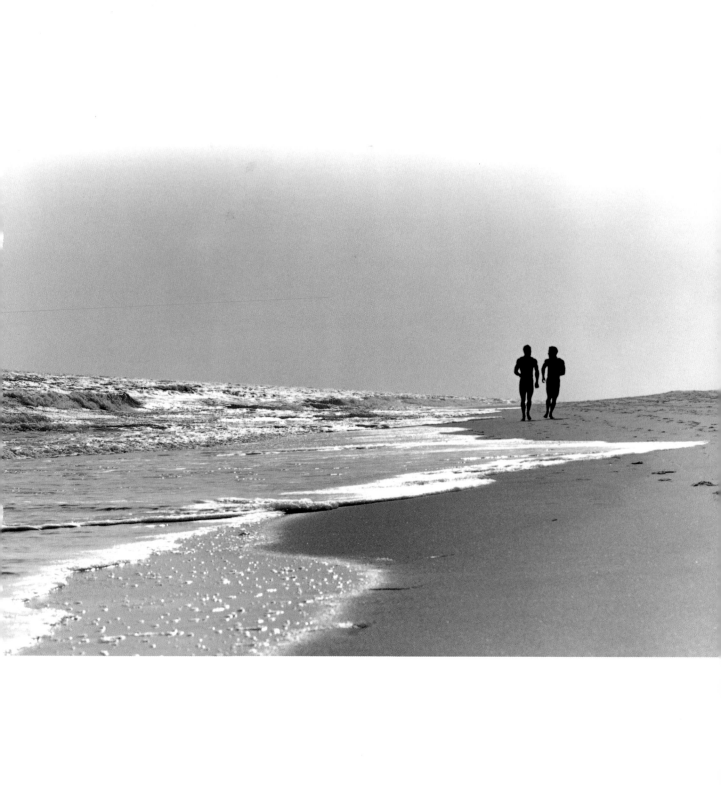

Also by David Morgan

BASIC TRAINING: A Fundamental Guide to Fitness for Men
(with Jon Giswold)

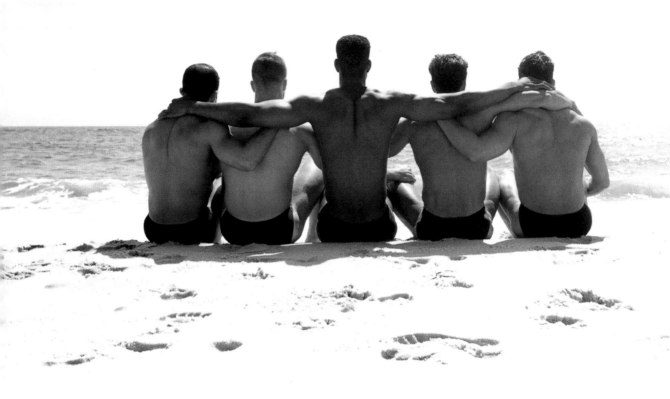

Beach

DAVID MORGAN

Story by Ernesto Mestre-Reed

ST. MARTIN'S PRESS ❧ NEW YORK

www.stmartins.com

Design by Gretchen Achilles and David Morgan

ISBN 0-312-26558-1

FIRST EDITION: OCTOBER 2000

10 9 8 7 6 5 4 3 2 1

In loving memory of

Michael John Young

and all the boys of summers past

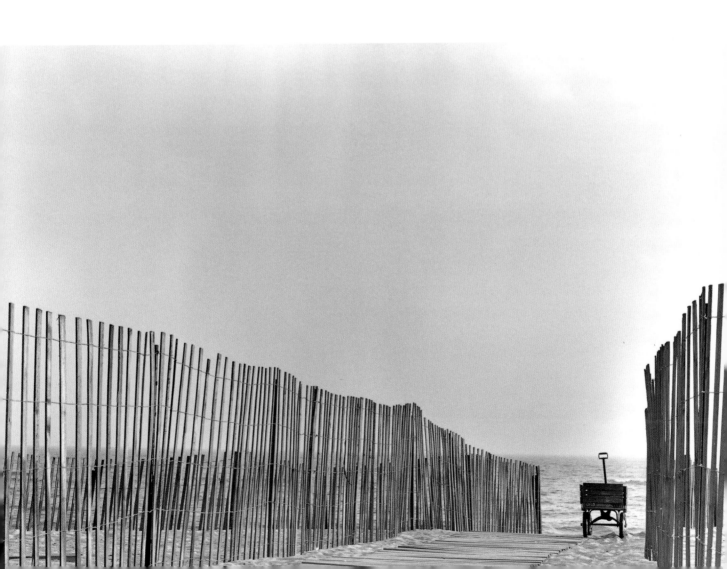

Models

Aldo Arago

Anthony Brandt

Noah Brody

Tony Brooks

James Brown

Nick Bruce

Jon Cisler

George Dellinger

Randy Henson

Edgar Jiminez

Steve Kinsela

Frank Lombardi

Norman Lundale

Jack Myers

Mark Montgomery

Dalvanne Pieres

Dave Purdy

Steven Sanville

Randy Spoonire

Charlie Tripodi

Bobbe Vagel

Location Crew

Timothy Reukauf, *production manager and stylist*

Cameron Wallace, *1st assistant*

Steven Lonsdale, *2nd assistant*

Amanda Butterbaugh, *location manager*

Celeste Randall, *grooming*

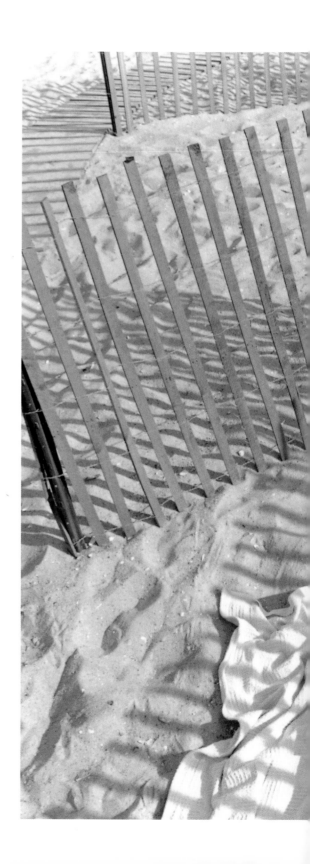

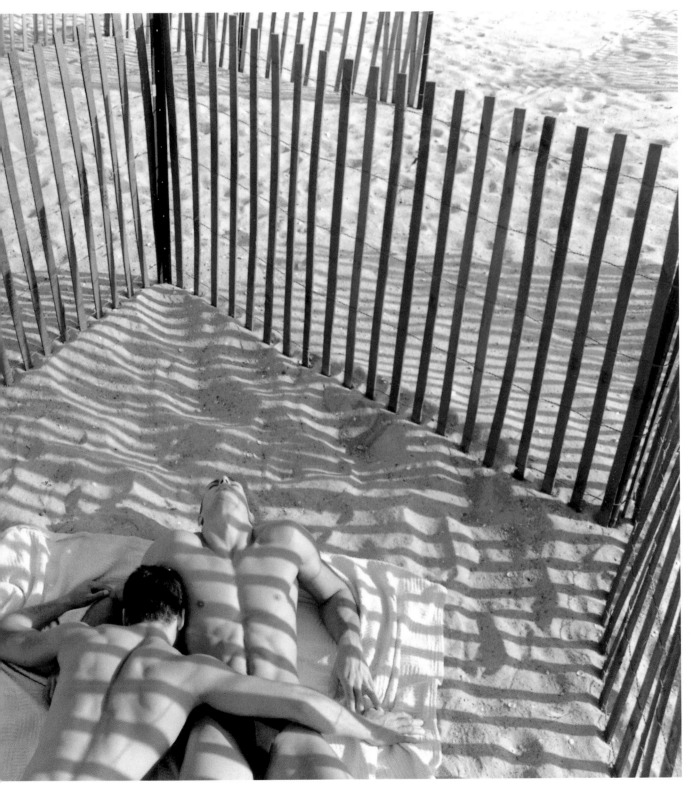

Preface

I often take a walk on the beach when the sun has just gone down. I wait for the others to leave, until the surf is calm. I'll walk up to the water's edge to stand quietly and wait. I keep enough distance so it might take a while before the first foamy ripple reaches up to tickle my toes. One wave, two . . . then finally it washes over my feet. This inevitably brings a smile. I regard this late-afternoon game at the shore as if I were inviting a very large puppy to come play with me. To lick my toes and say, "Hi, Dave! Wanna play?" It is my private ritual at the beach. A quiet moment with my benevolent puppy-god who loves me unconditionally.

I am in awe of the sea. To me the ocean is the single largest being I'll ever touch in my lifetime . . . with my toe. Surely, it's God himself enveloping the entire planet with his brimming life. So it is here that I stand at the very edge between land and God to take a moment to reflect on how insignificant I seem. And how lucky I am in this life.

I realize everyone has his own private passion for the beach. For most it's a retreat, a safe haven, a place where you can cleanse yourself of urban concerns and brace yourself for another week of life's little fires (to be put out all over again). For men of urban persuasion it holds a unique place in our lives. Existing as we do on the fringe of society, we gather, as is fitting, at the very edge of the land just to be ourselves. It seems we own the beach, make up new rules, and exist a bit more comfortably.

This book is not about a particular island where I enjoy my summers. I could never convey the full scope of that extraordinary community where these pictures were created. You won't find much of what that famous retreat is known for . . . its wooden walkways, unique architecture, and crowded social affairs. This book is, instead, simply about our enduring fascination with the sun and this place at the edge of the land where we've claimed our own private social rituals. And for added value it's populated with a few of the very handsome men who play there.

Sun, sand, surf, and men. Those were my ingredients one early September when I created this body of work: ten perfect sunlit days, twenty-five friends, a wonderful, capable crew . . . and a couple of hundred rolls of film. Those who participated in its creation cherish our memories of those ten late-summer days.

Oh, and there is me, of course, between these pages. After all, this is my fantasy. My own very lucky view of the Beach.

DAVID MORGAN,
New York City
Mid-winter, 2000

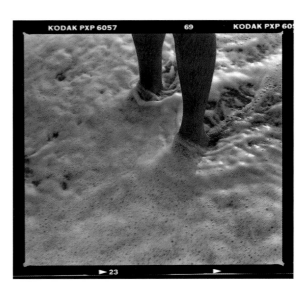

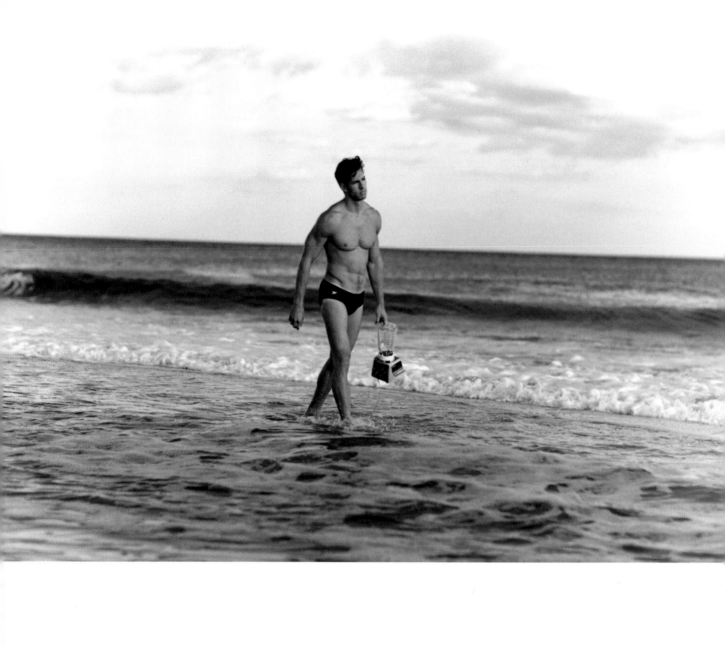

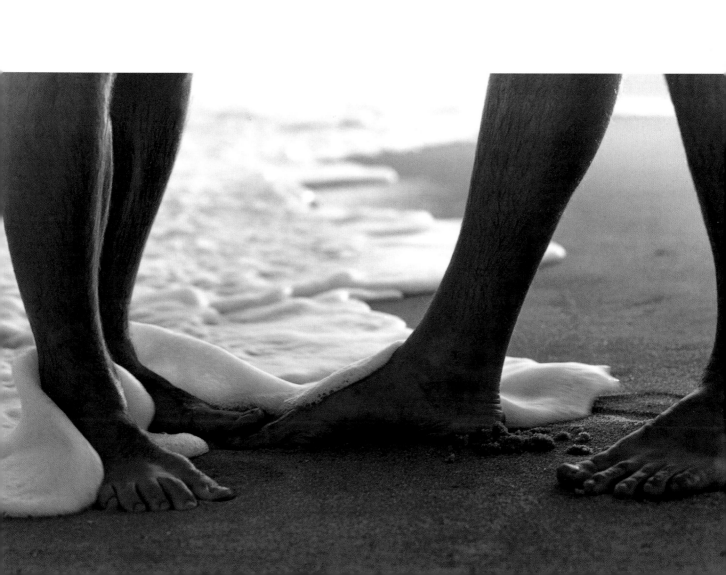

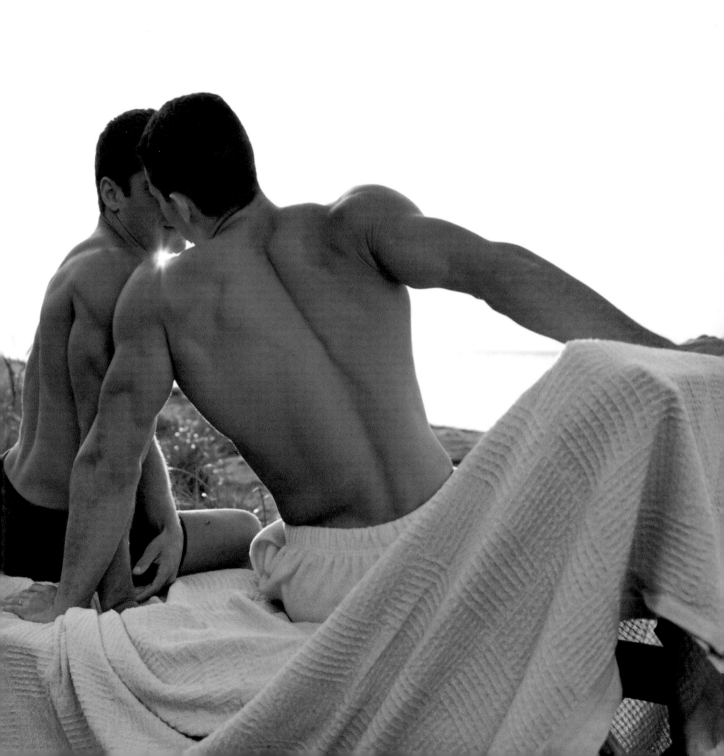

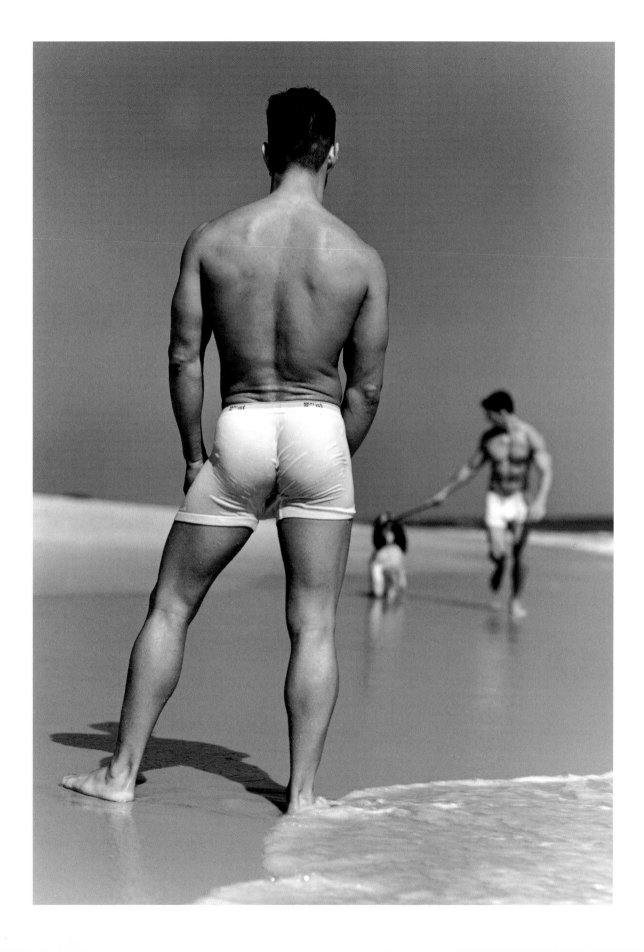

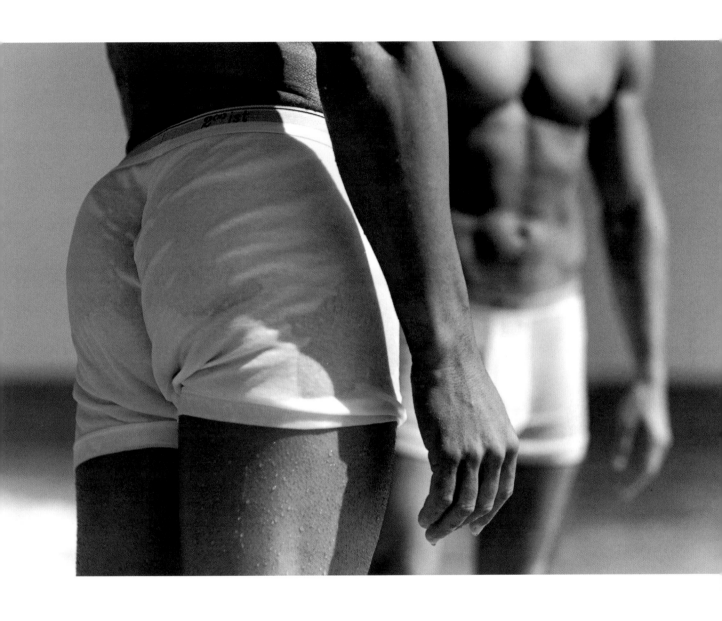

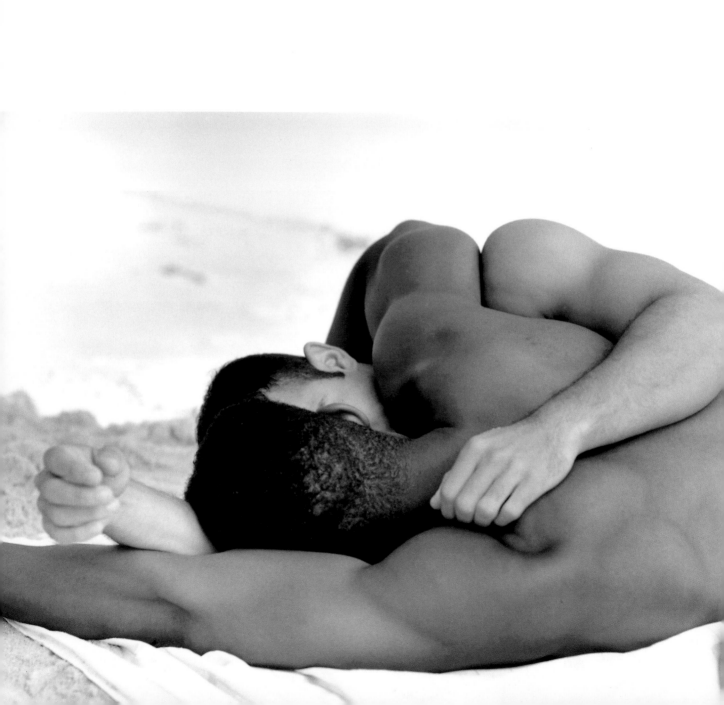

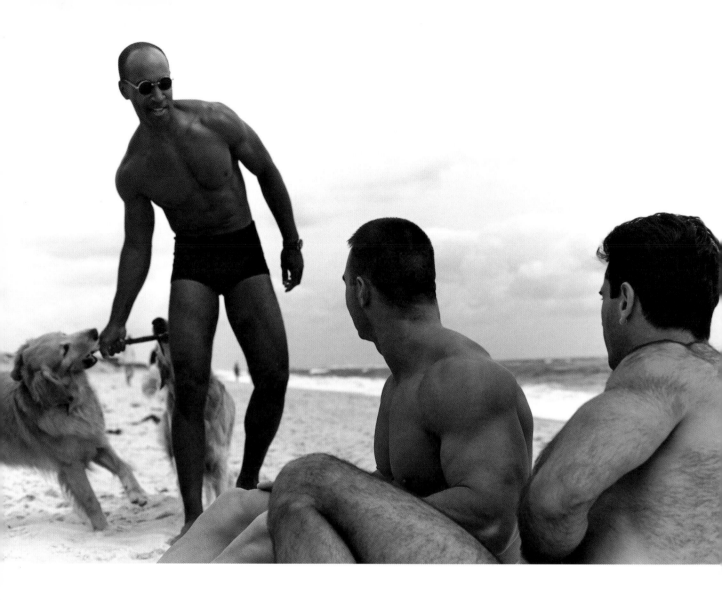

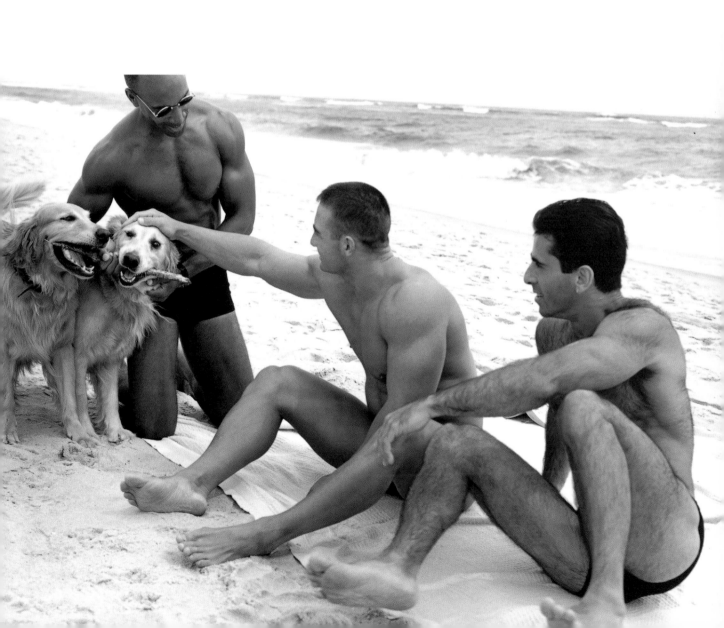

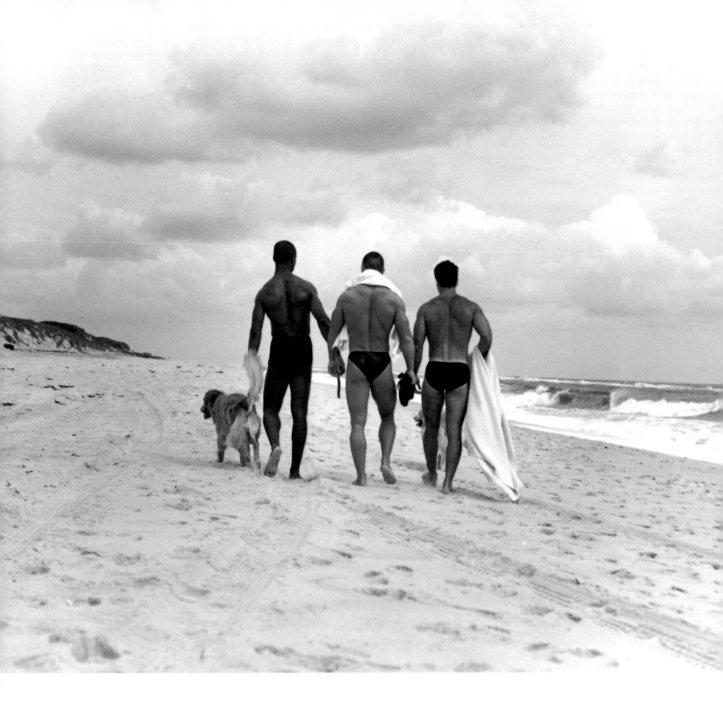

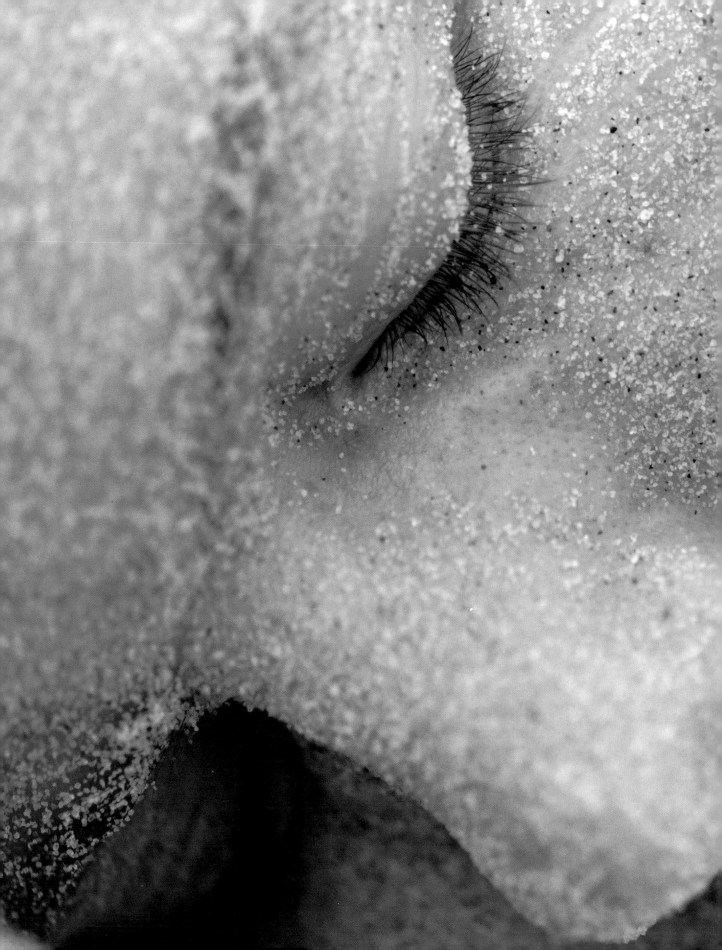

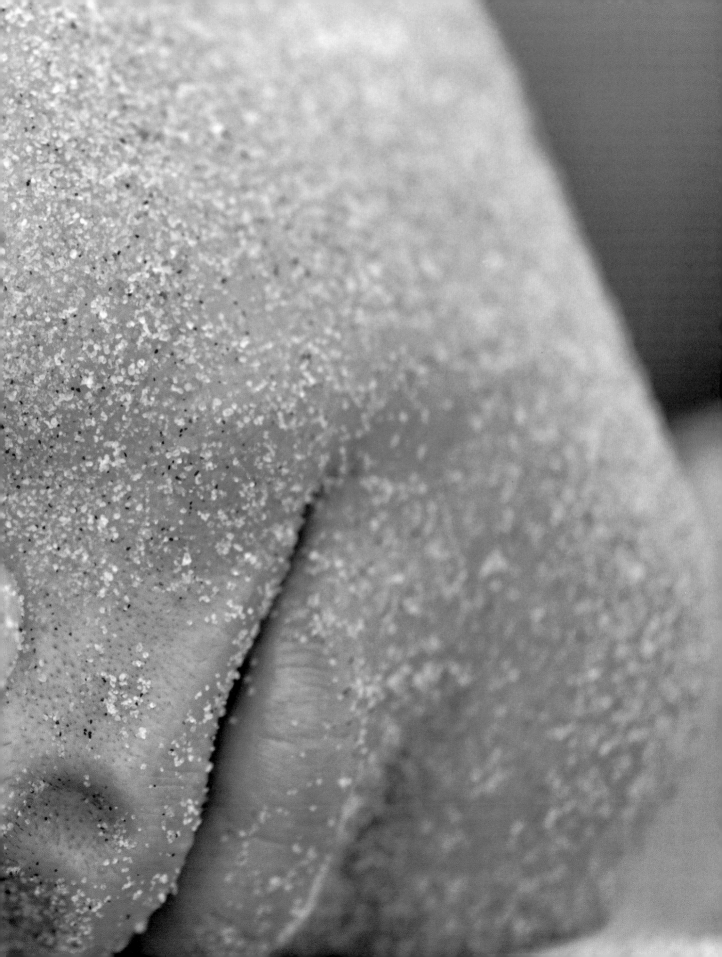

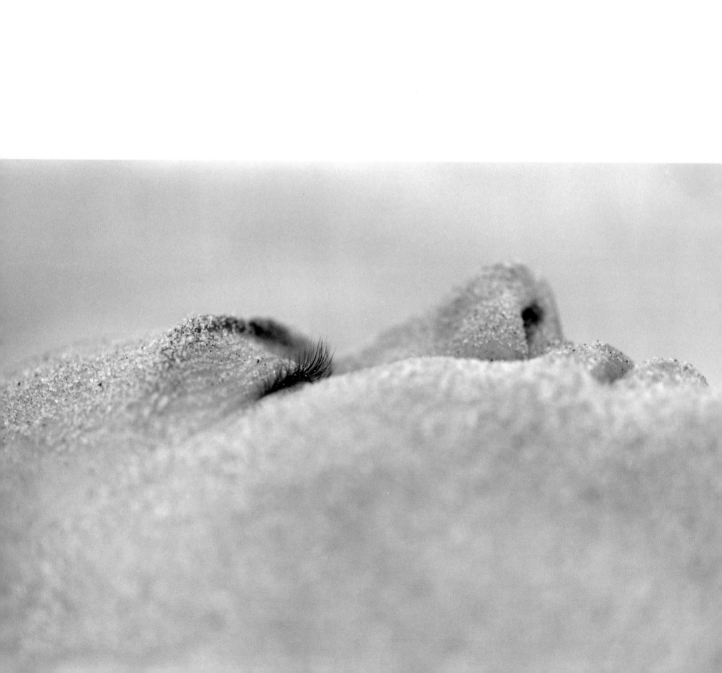

The sun stirs awake almost alone, but there are some there for it: the dolphin rending the surface of the sea with its inimitable crackling joy, scanning the black-green waters for the boy who was cast from the sinking raft; the crab burrowing out of its sand-sleep to scavenge for breakfast, tracing half circles around a naked foot; the shirtless old man with his detector, listening for the siren call of buried treasures, blind to the sober beauty on the horizon—a naked boy who has been cast on the shore, where the pebbly sand has become his mistress, touchy everywhere, a grainy veil on his fallen head. The deer who has wandered the night looking for its own, its brown eyes dumb, rubs its nose along the ridges of the fallen boy's ear and twice licks his salty neck, as if it were marking him, and then wanders off. So some are there for the stirring of the sun: no thing awakes fully alone.

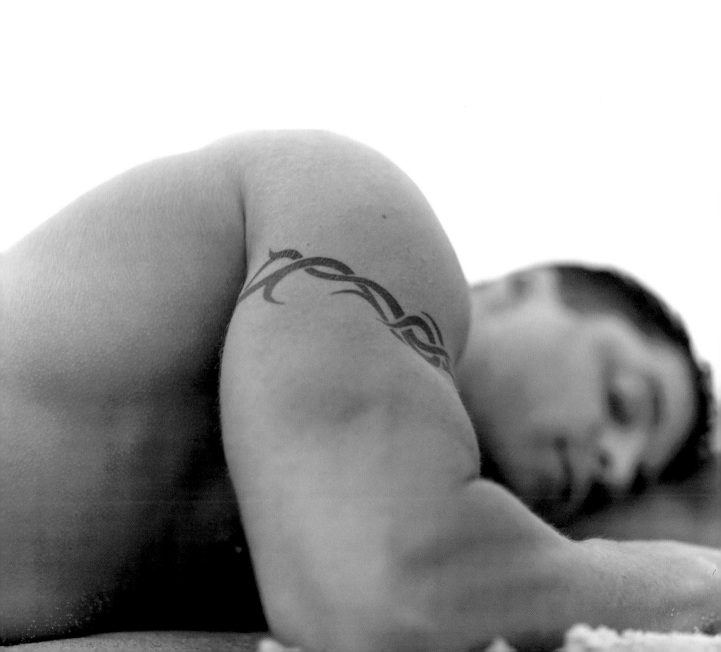

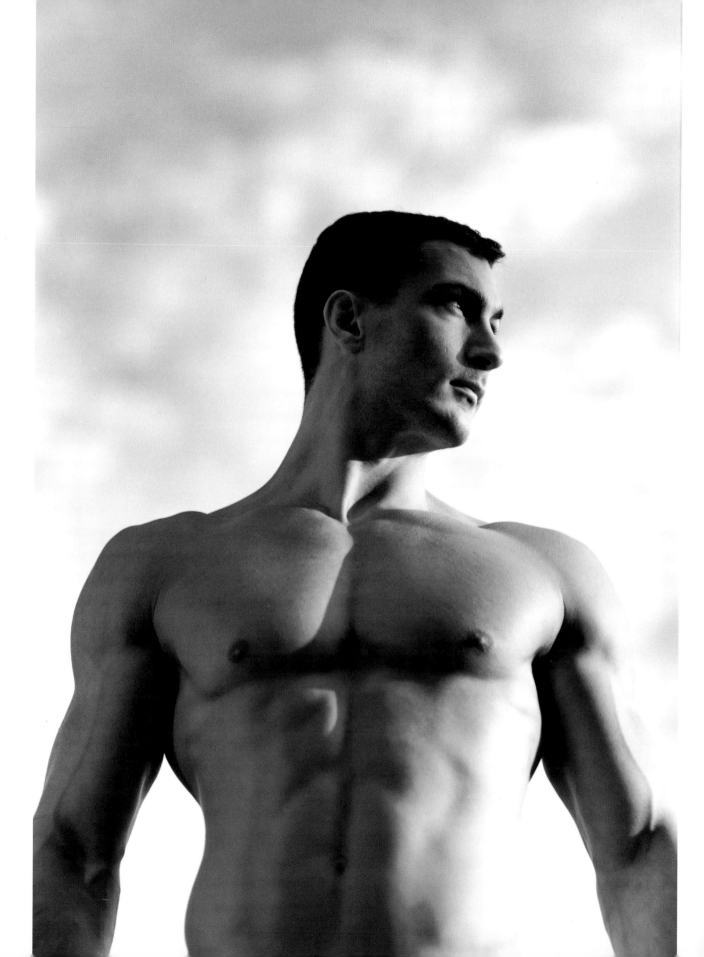

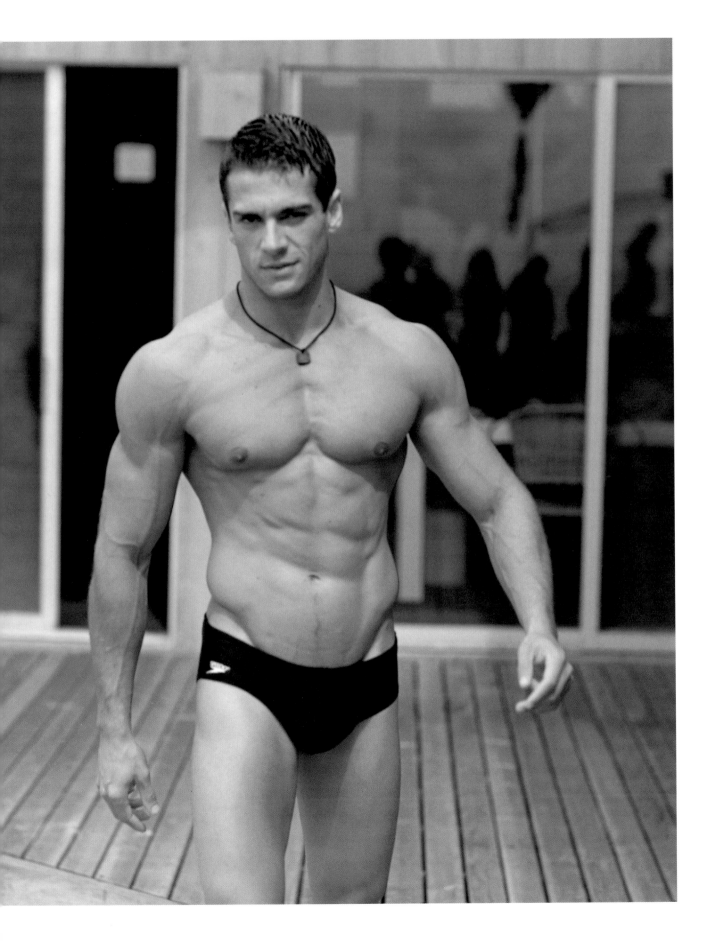

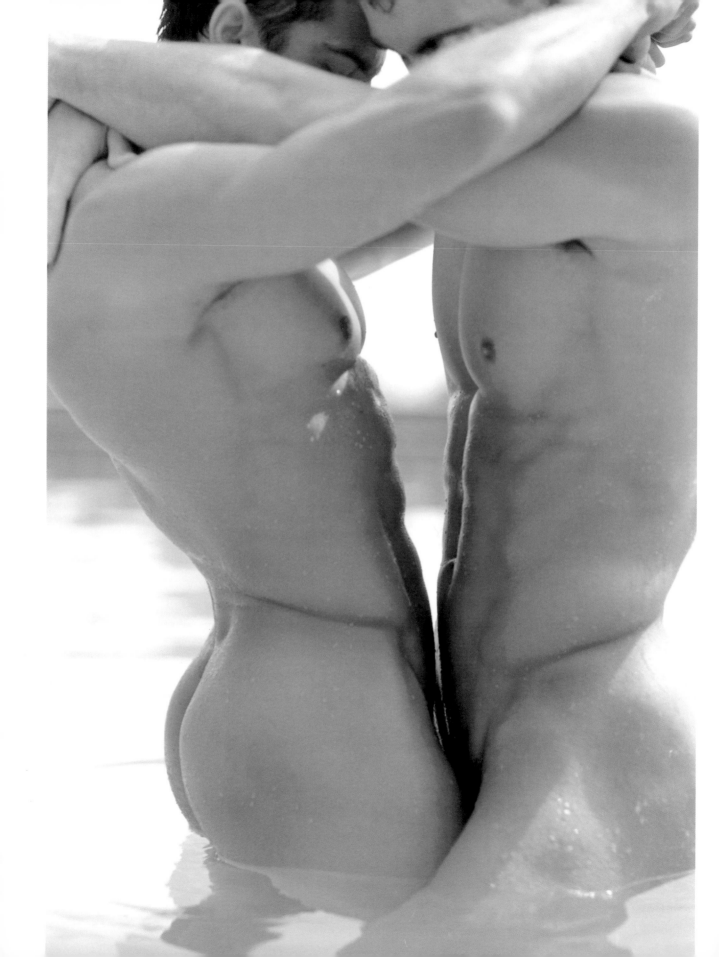

At first it is coy, its thin quivering rays as gentle but as pressing as the brush of a beloved's hair. It tickles the throats of ferocious birds. Then, in a rush, it throws off a thick blanket of clouds and its sinewy limbs stretch across the edges of the world—there is no creature, no thing, to which it does not offer its unadorned vigor, whereas the toiling sea seems not to have slept at all. She hides under dark mantles that ripple with the harmless west wind. Though she too has offered. During the night she has given up one that she could have made her own, has let the sand have the naked boy, has offered from her darkness this unspoiled treasure, has let the sun, the crab, the deer, the west wind, have the naked boy. She pulls back her slippery cords, though she will return.

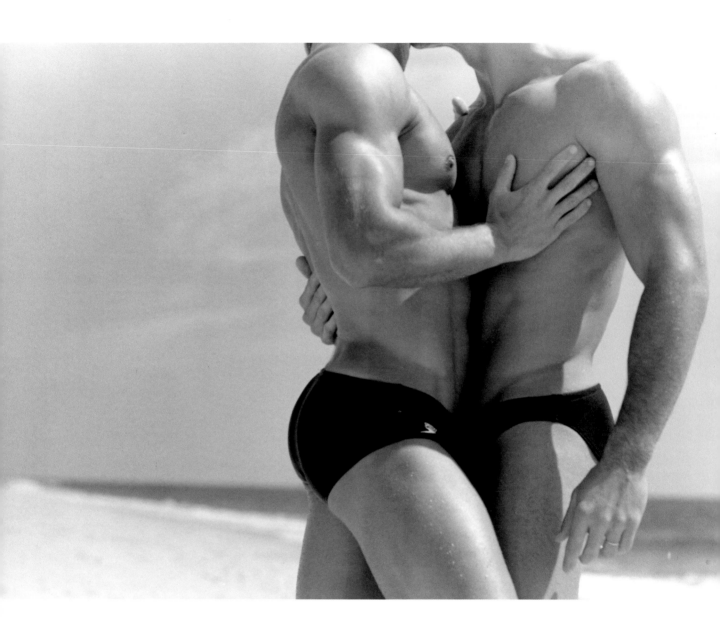

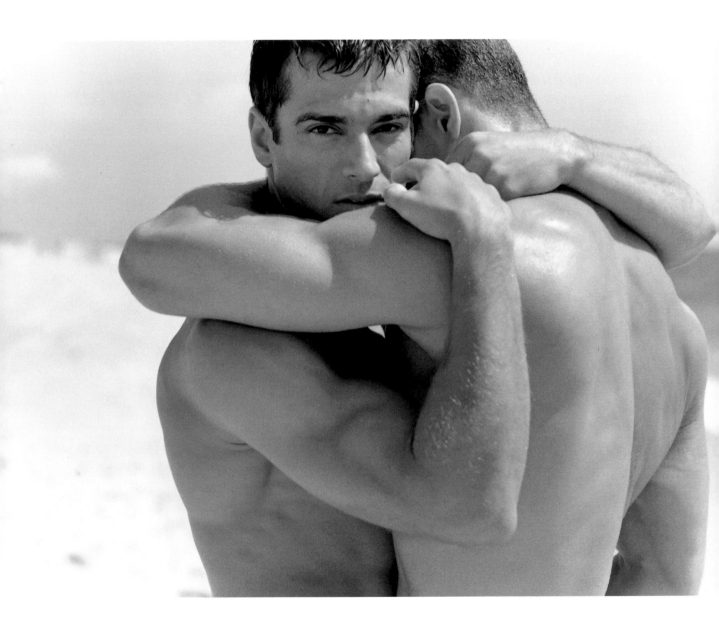

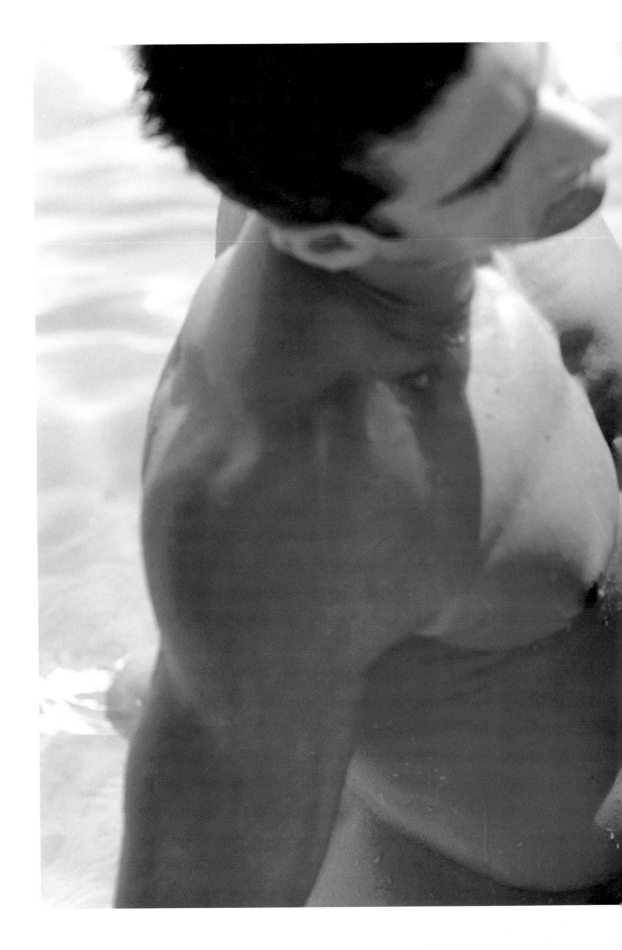

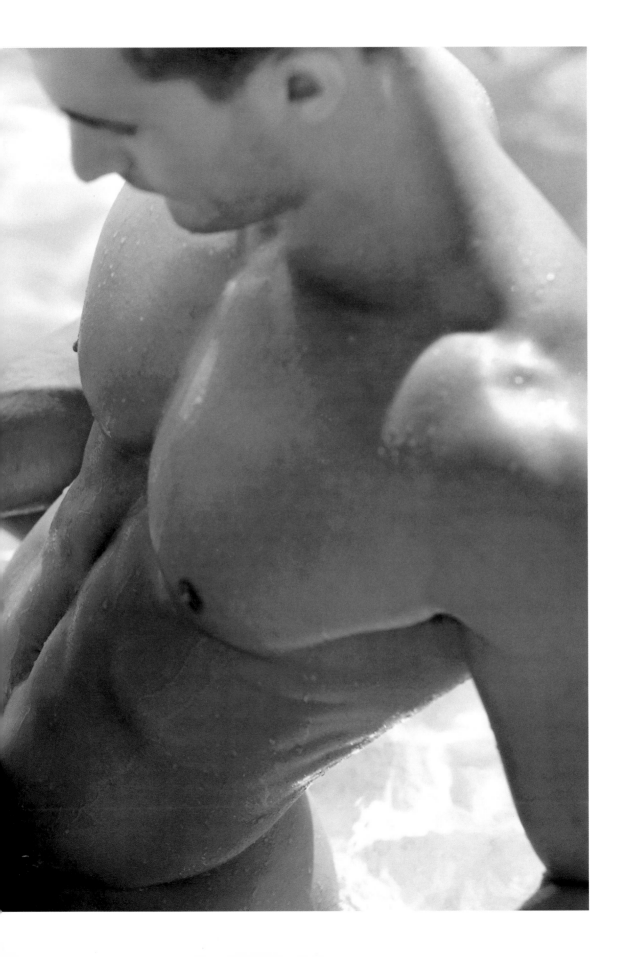

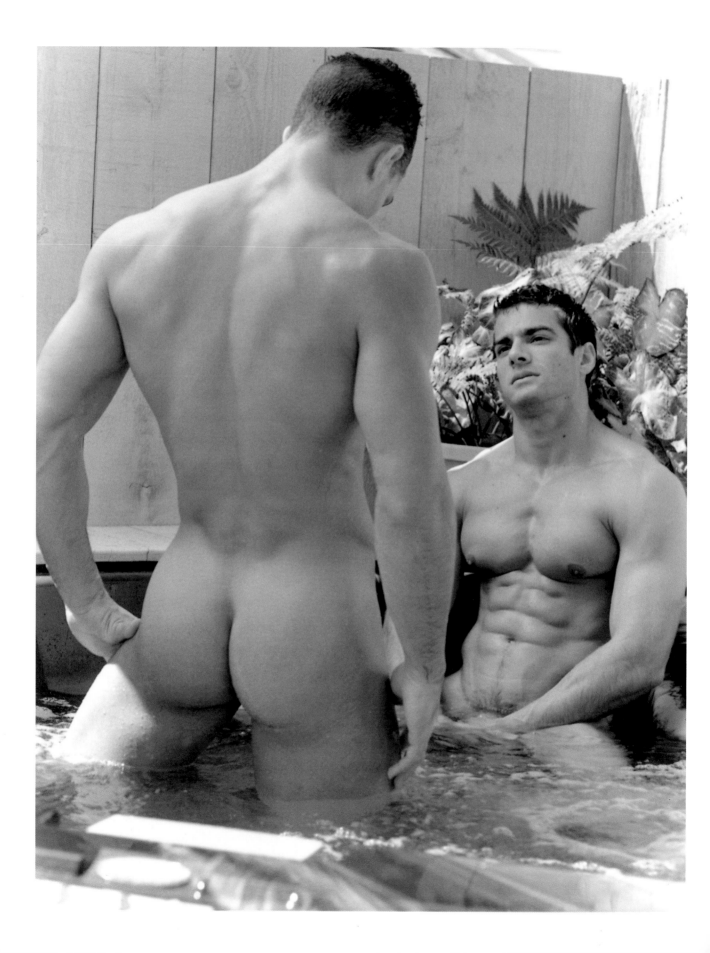

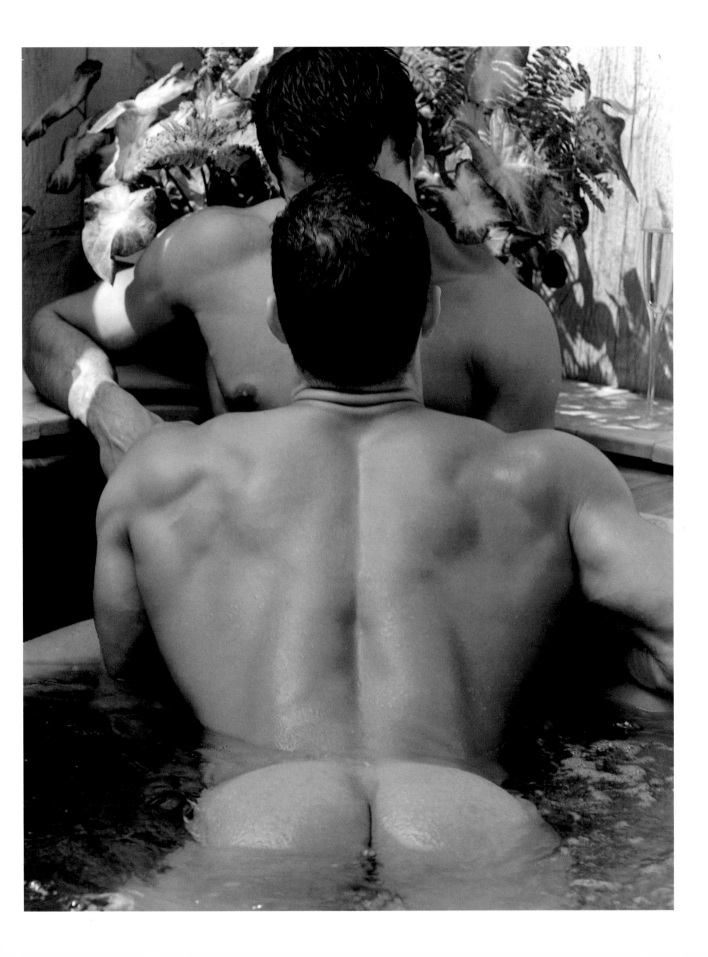

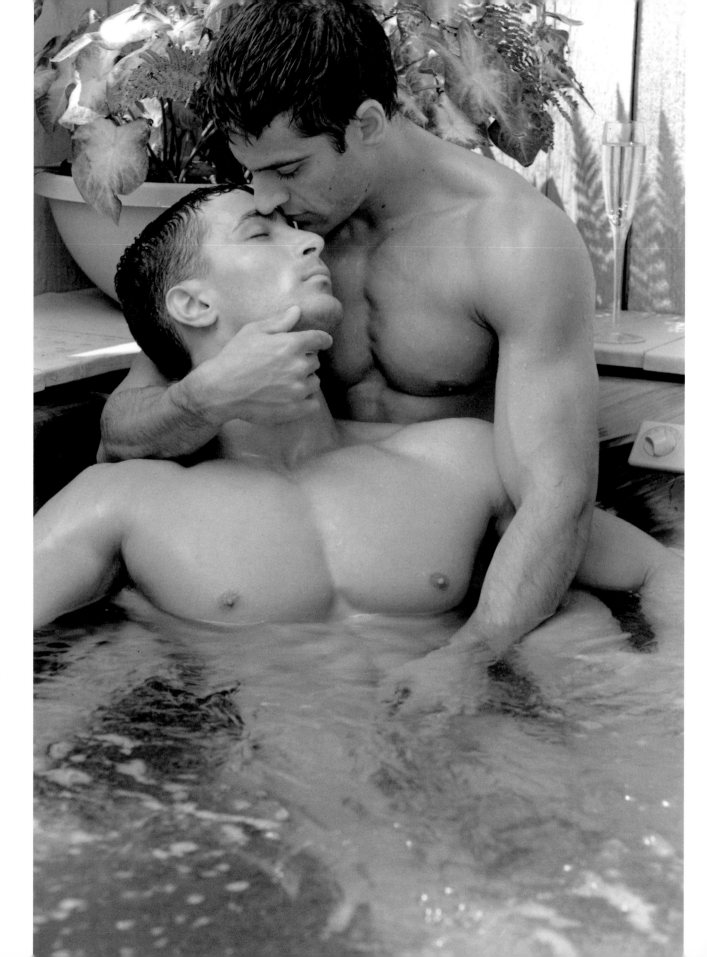

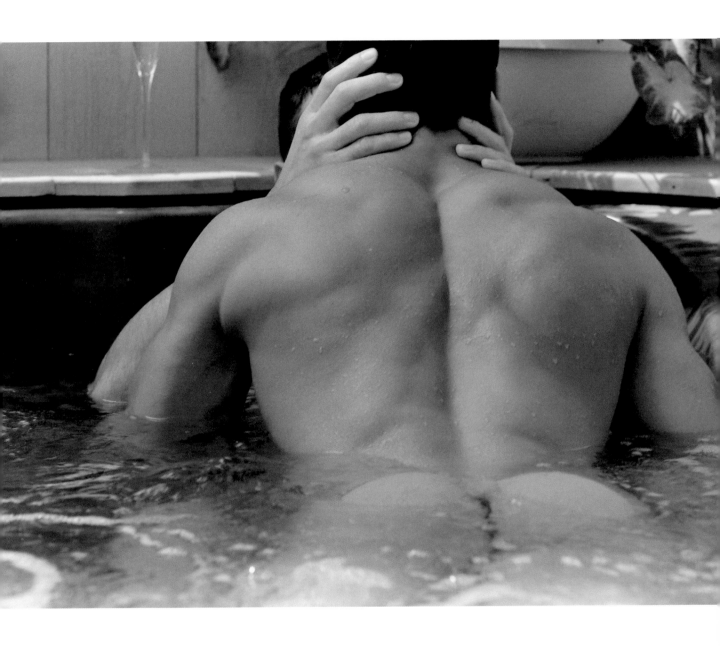

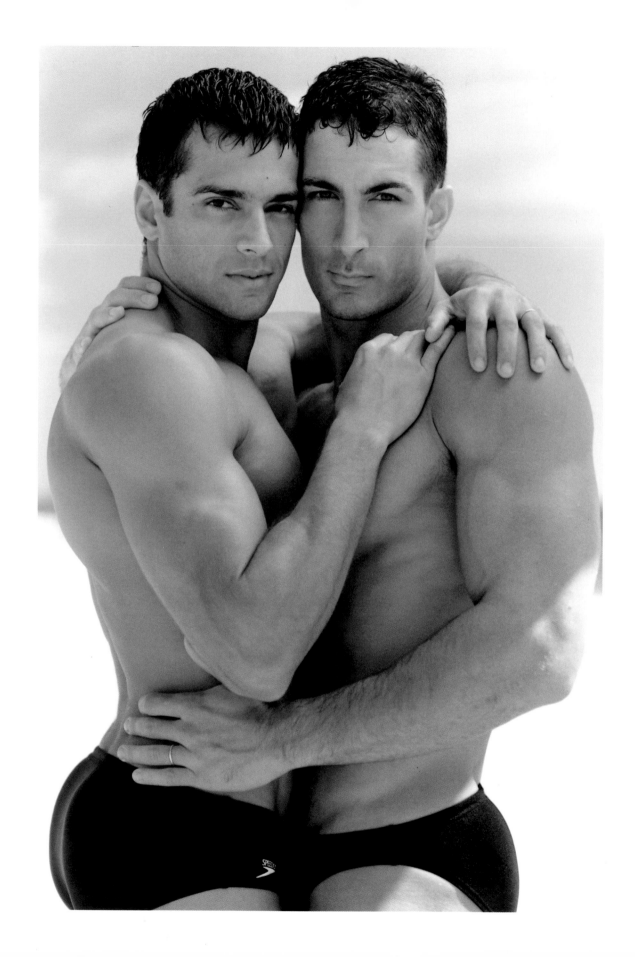

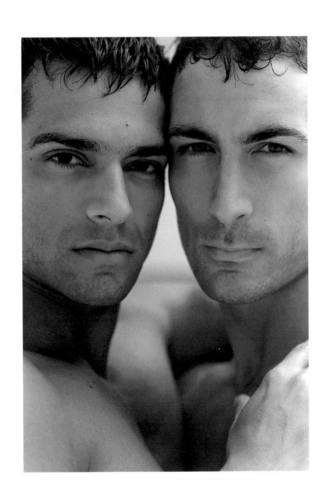

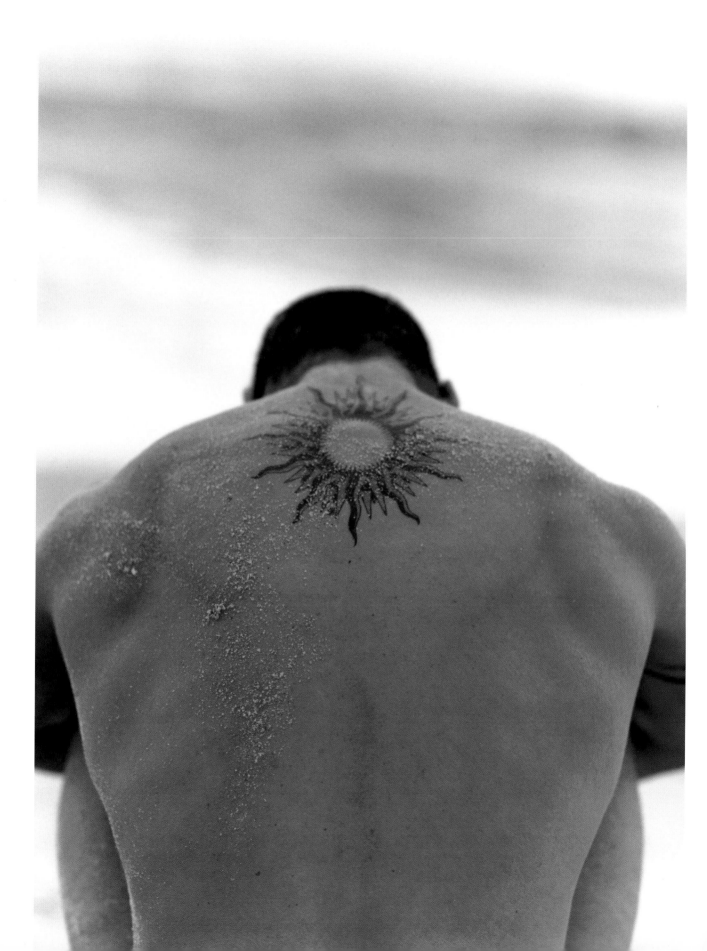

The boy lifts his head; he pushes his torso up and sits on his knees. The sand has made an impression of his body, mysterious and fragile as a cloud. The boy waits, his hands on his thighs, his back to the sea. He does not brush the sand off his face, his chest, his belly, or his arms. He sees in his shadow the width of his shoulders, traces the soft hairs that grow around his dark nipples, and runs his finger lower to the ones around his belly button that loop down to the tuft that hides his sex. He wraps his arms around himself as if he were another. He cannot remember growing into a man, cannot remember any life before the sea. He lets the sun graze with its bristling reach the spot between his shoulder blades, till he feels a shadow of its image branded there like an elegant bruise.

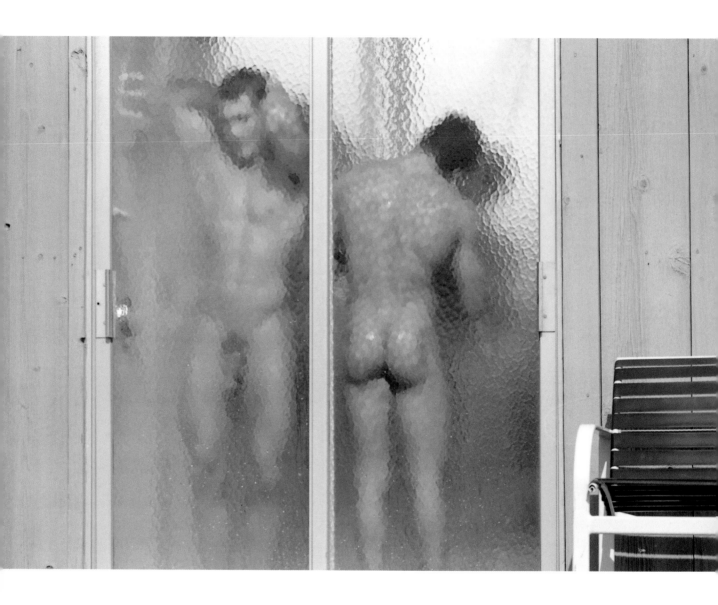

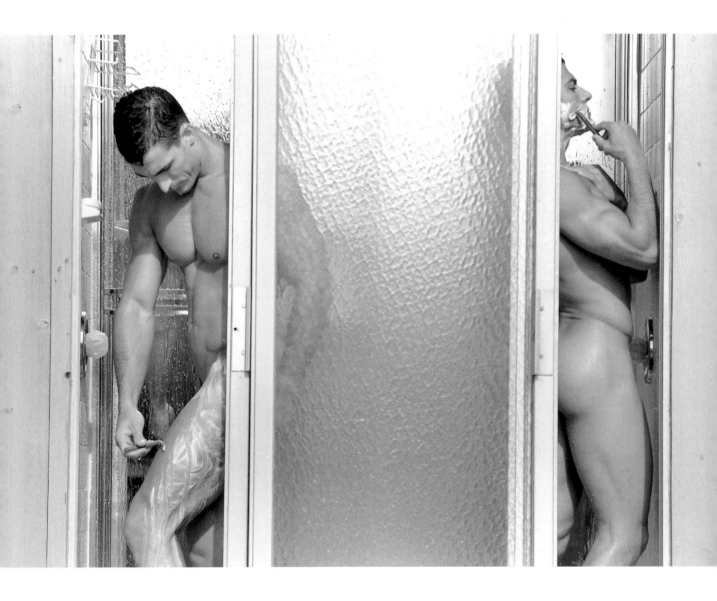

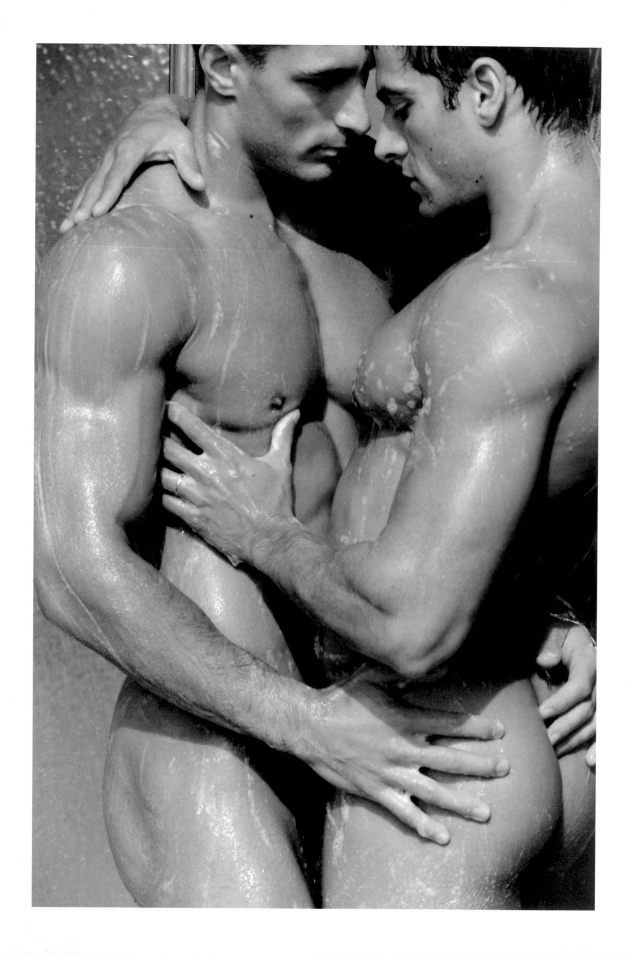

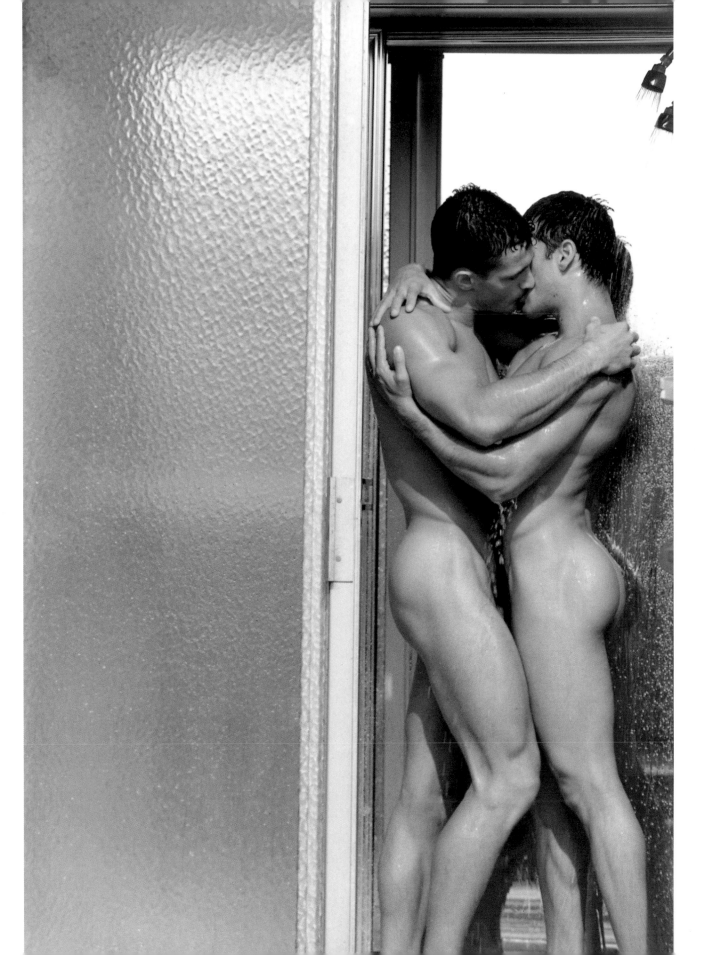

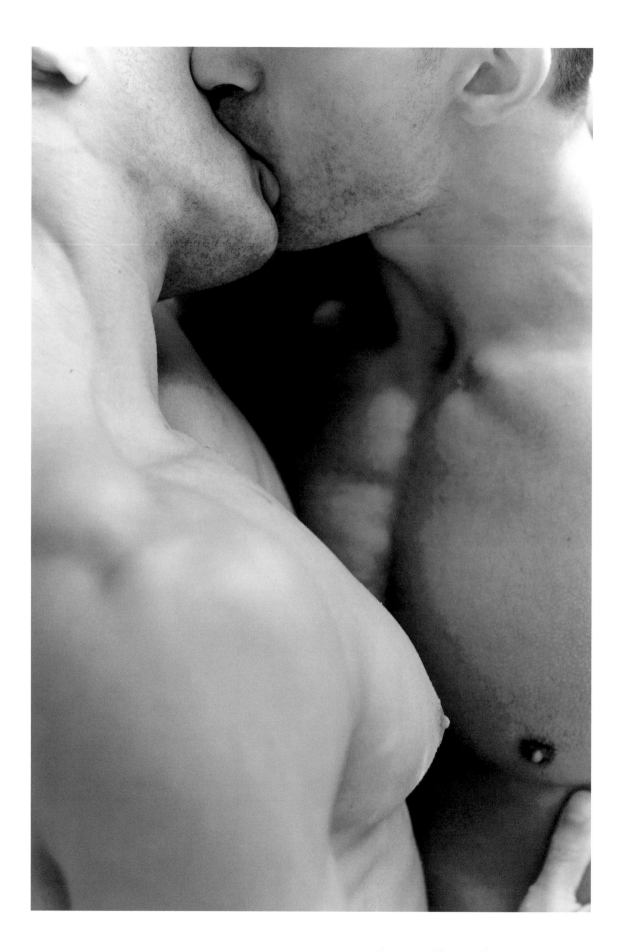

But no thing awakes fully alone. Others come for him and wrap him in their towels, insistent on saving him, but when they try to brush the sand off him, when they try to lead him to the edge of the sea to wash him, he turns away, and only when they promise not to do it again, does he let them come near him once more. He did not see them approaching, does not know where they came from: from which one of the wooden houses on the shore, sitting precariously on spindly stilts like acrobats, did they emerge?

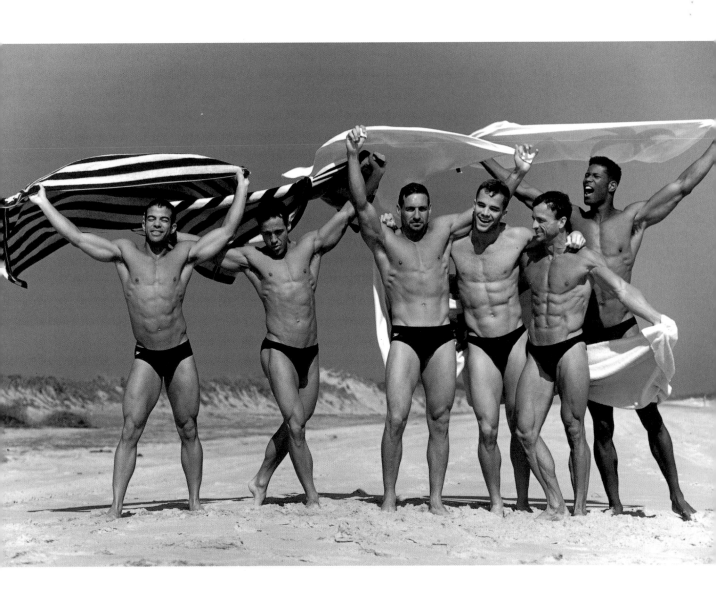

46

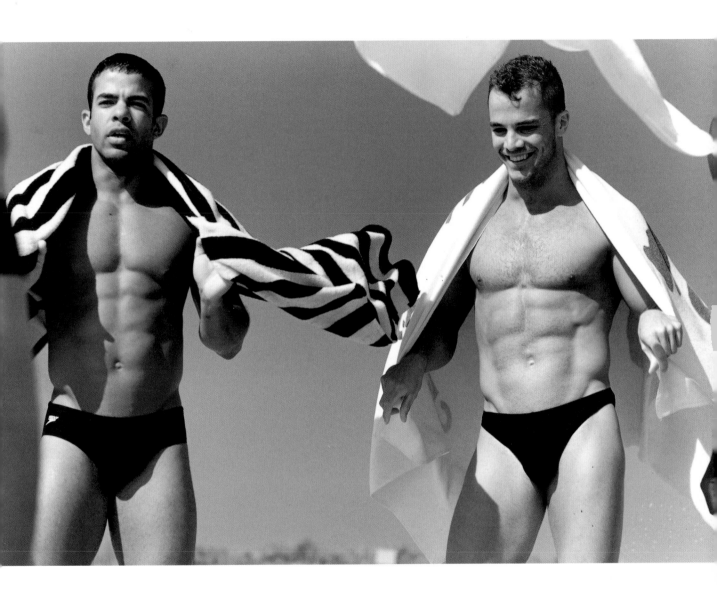

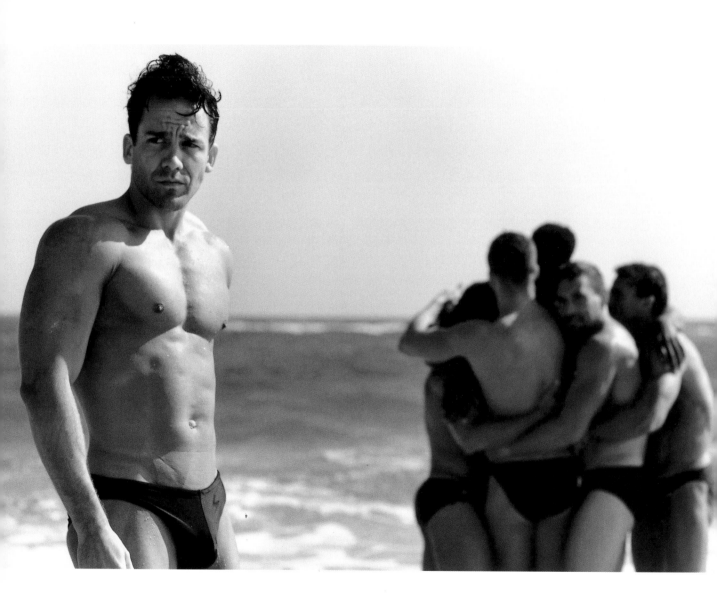

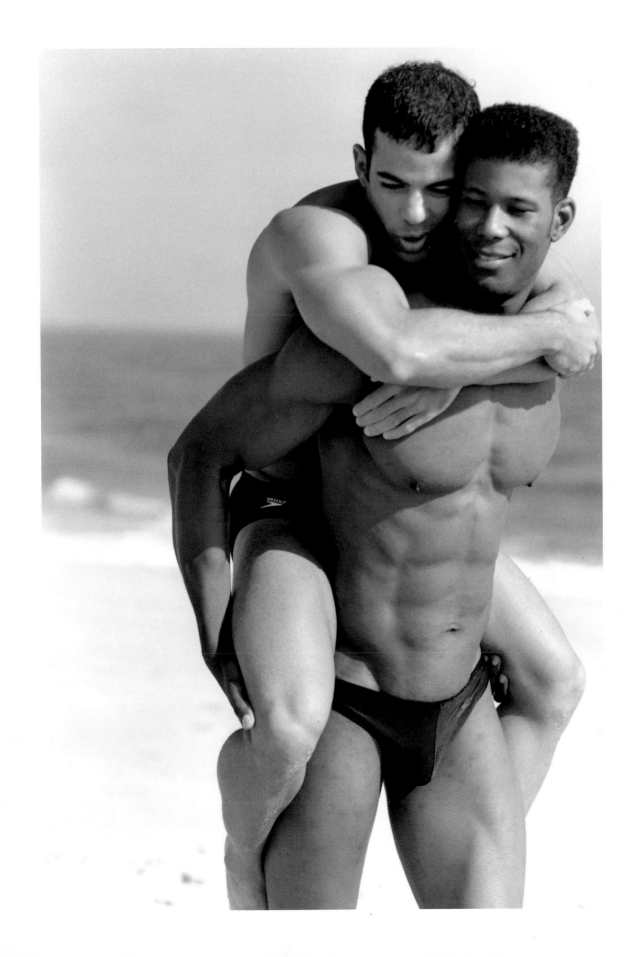

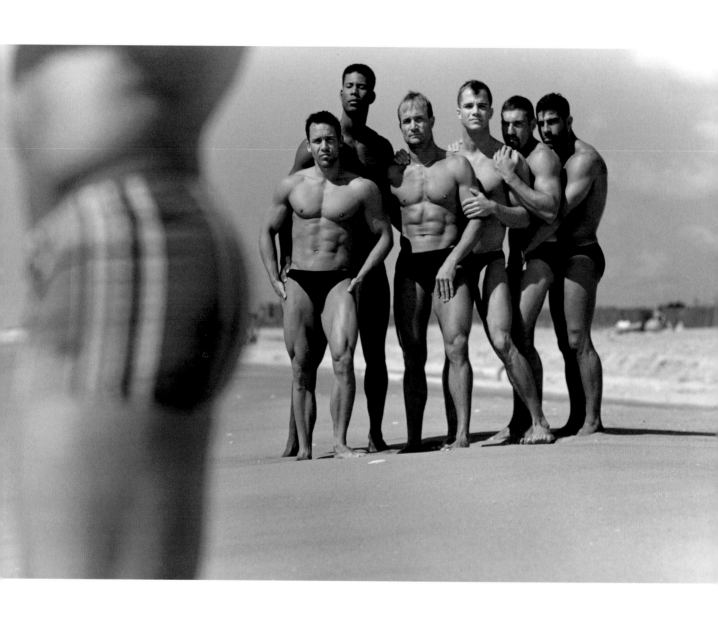

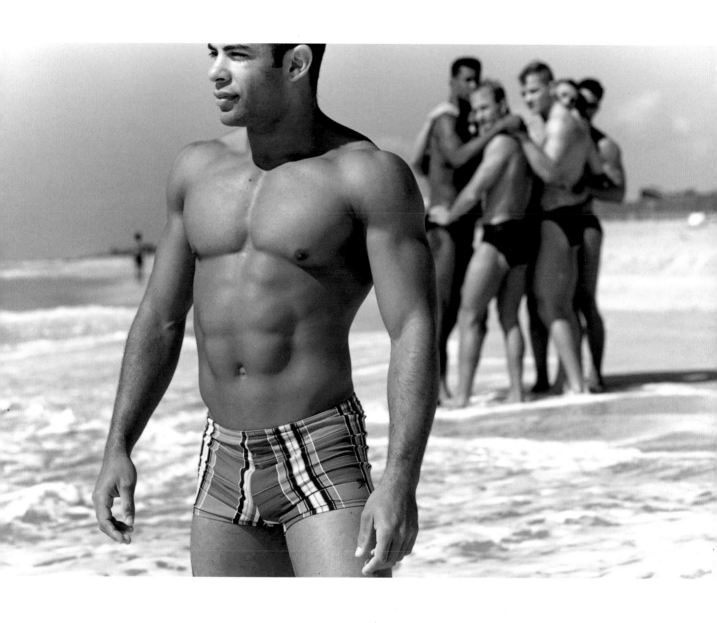

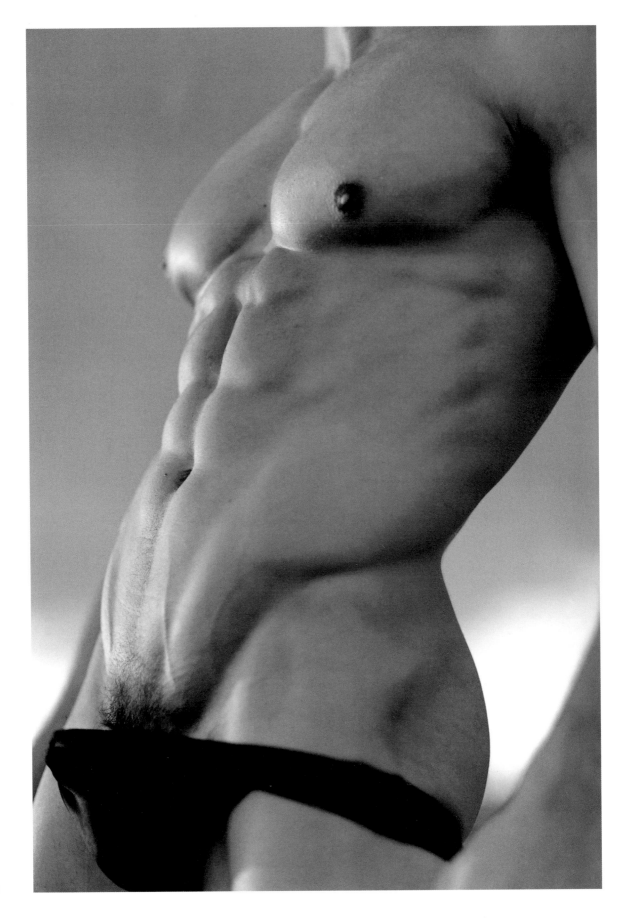

He gives them back their towels and again moves away from them, farther from the reaches of the sea, and sits, this time facing the water, his arms wrapped around his legs, and watches as the others wade in and as they race back out of the water like a regiment of horses, their legs indistinguishable from one another, their naked torsos erect and high like proud equestrians. They do it again and again, as if performing a drill, as if the foamy tide depended on their churning force. And when finally they stop, they lounge on the sand—their limbs tangled with each other like the branches of neighboring trees, their bodies heavy and thoughtless as somnolent cats. And the waters retreat from them.

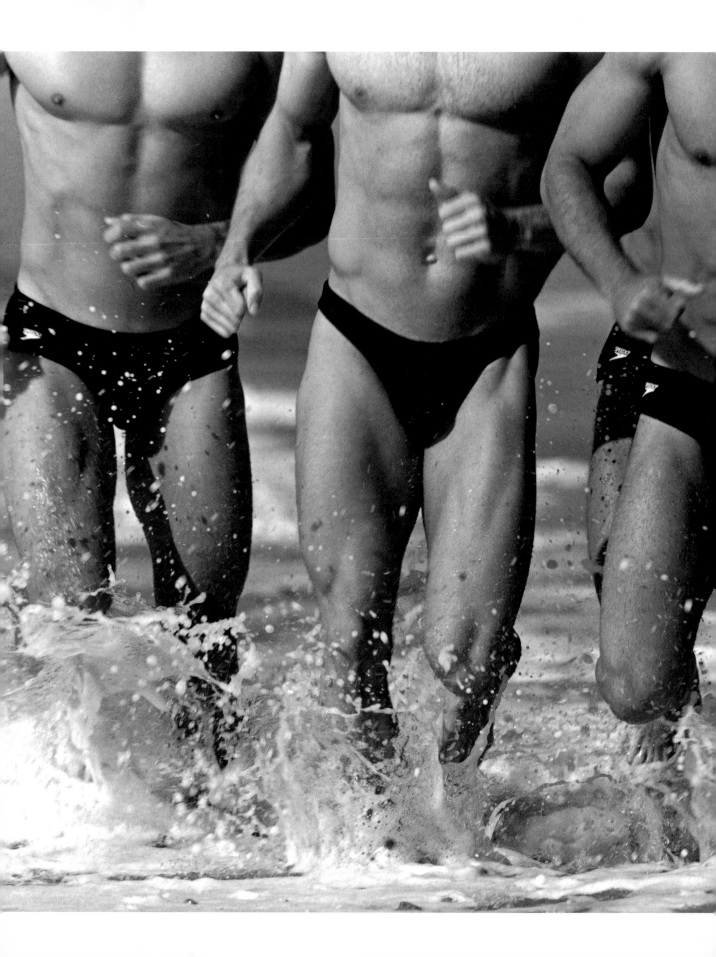

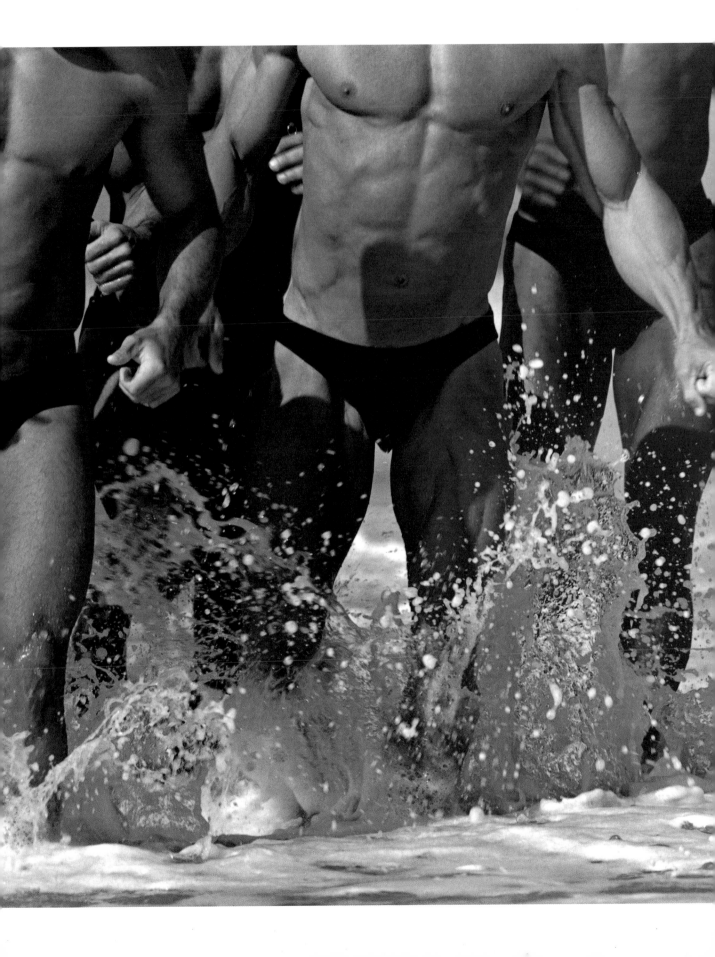

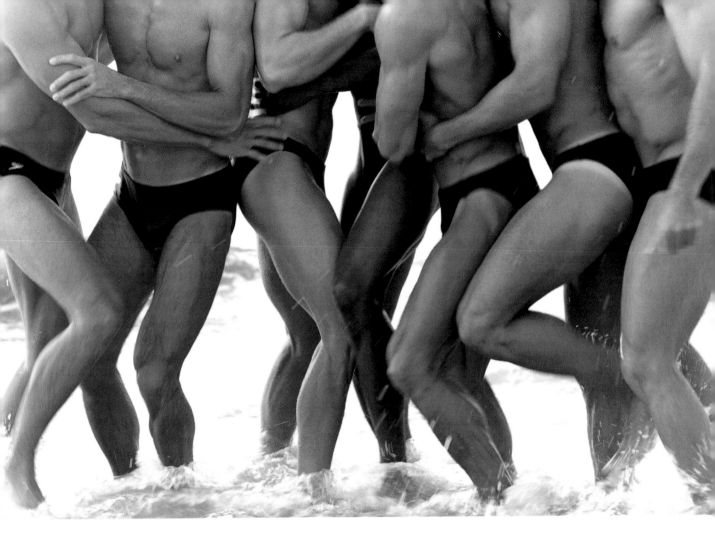

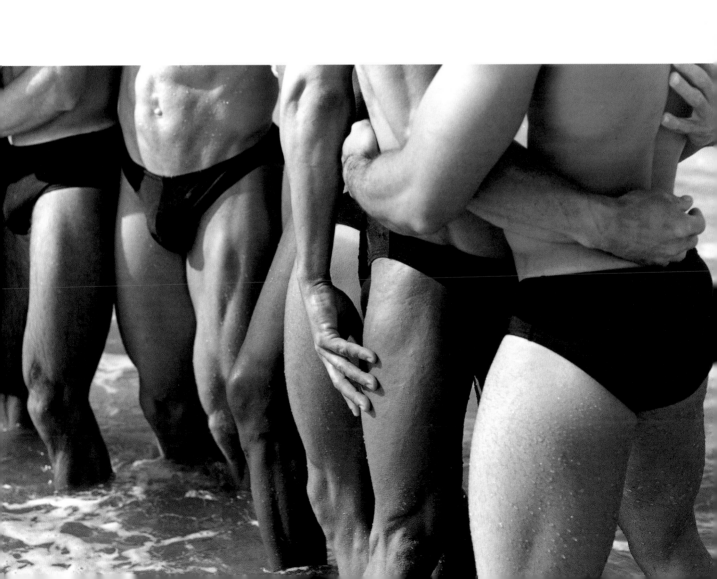

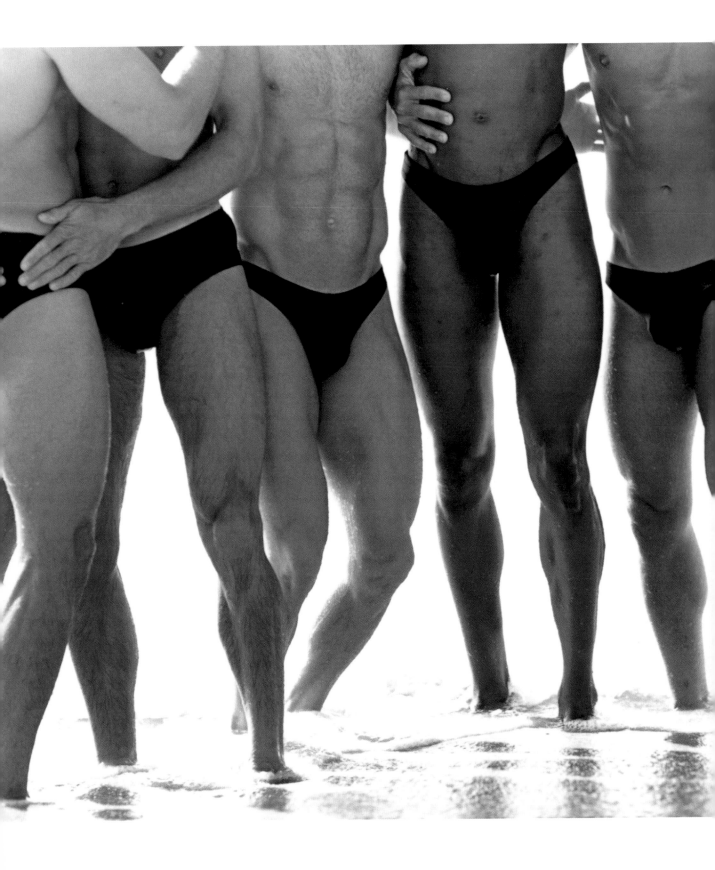

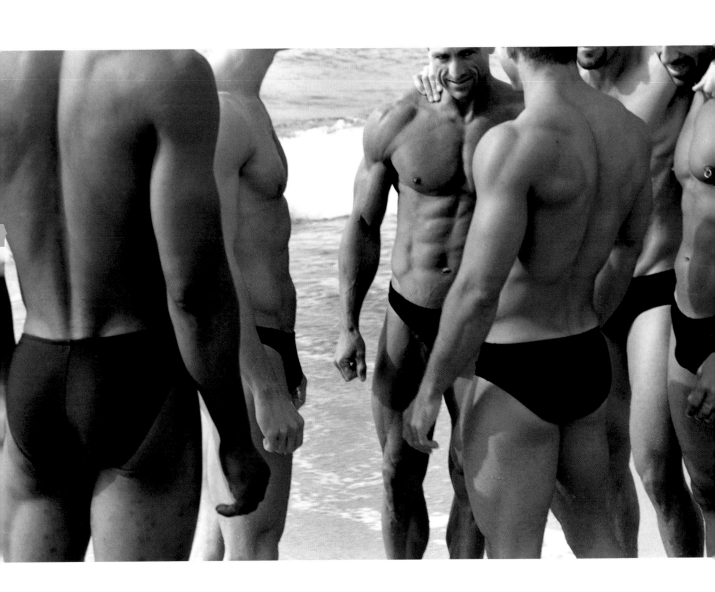

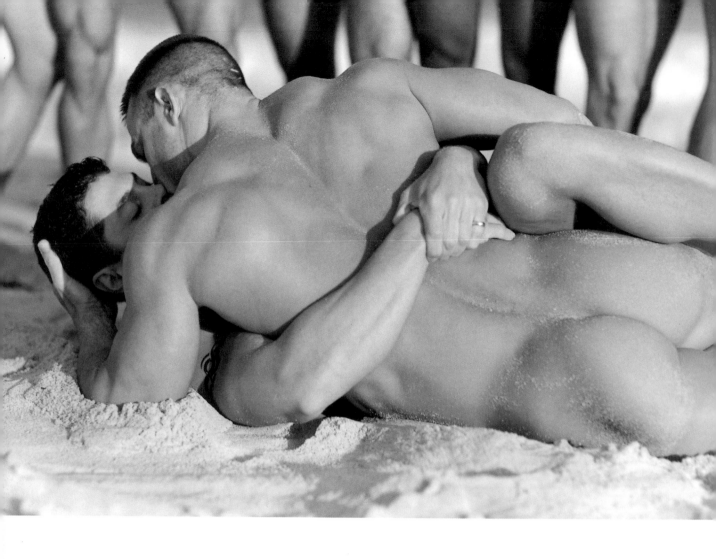

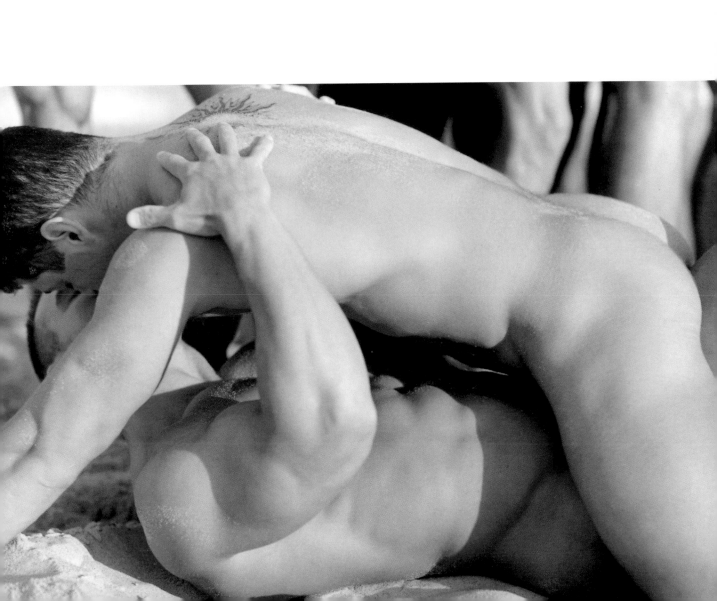

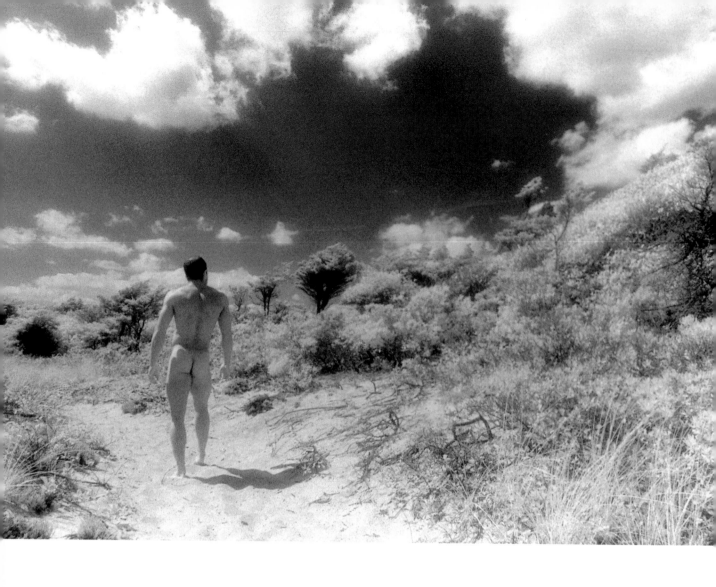

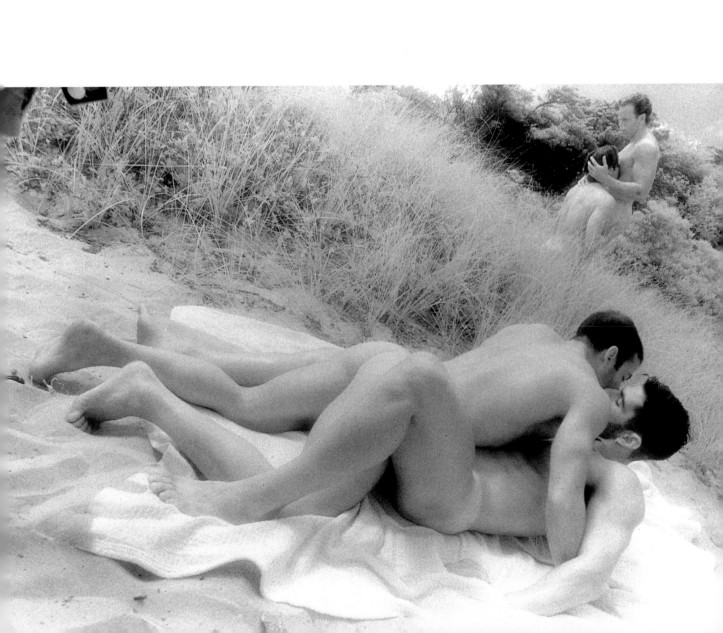

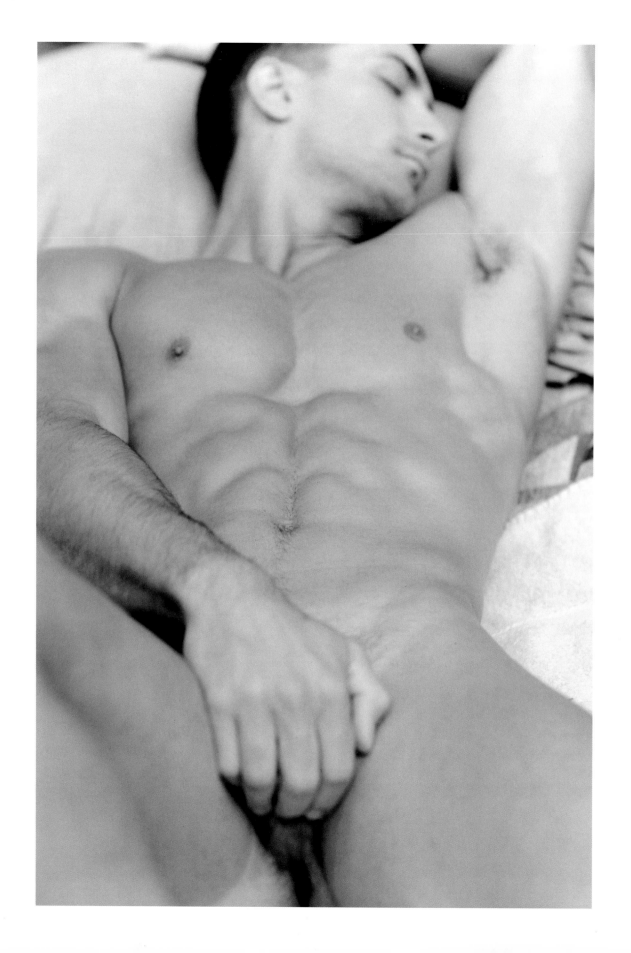

For a while they ignore the naked boy, and he sits and lets the morning pass, and watches them doze, their bodies gleaming in the white sand, the sea water like beads of forgotten fires sparkling on their skin, and he burns their shapes into the plates of his memory, so that he will remember something of this new life, so that later he will dream about the black narrow band of a swim trunk ardently hugging a hip, about the ball of a shoulder sloping to an outstretched arm, reaching for the vastness of the early afternoon, about veined horselegs that had grown, like a lizard its tail, under the torsos of the naked riders, and about heads bowed over by a soporific sand.

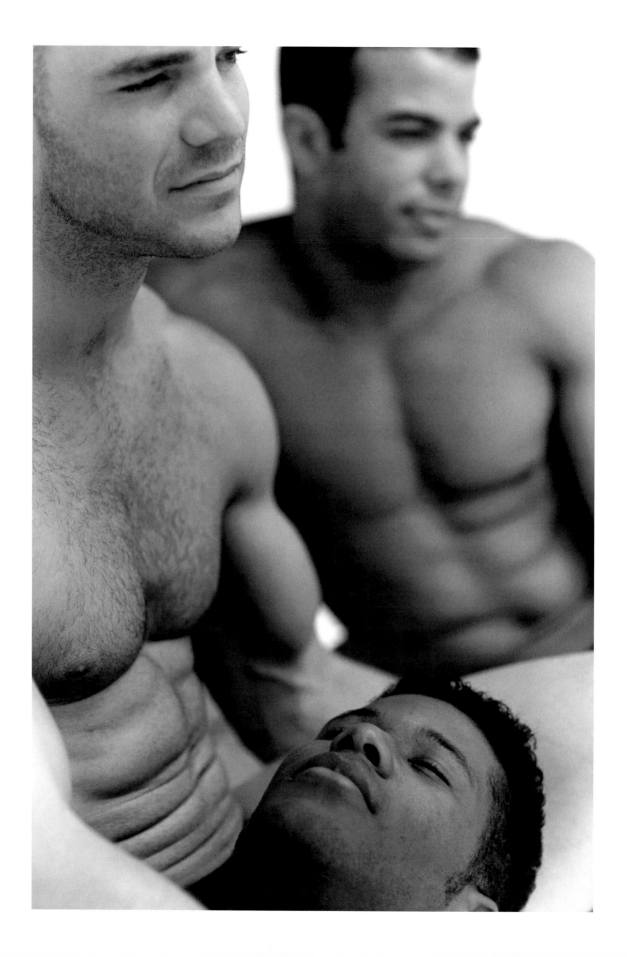

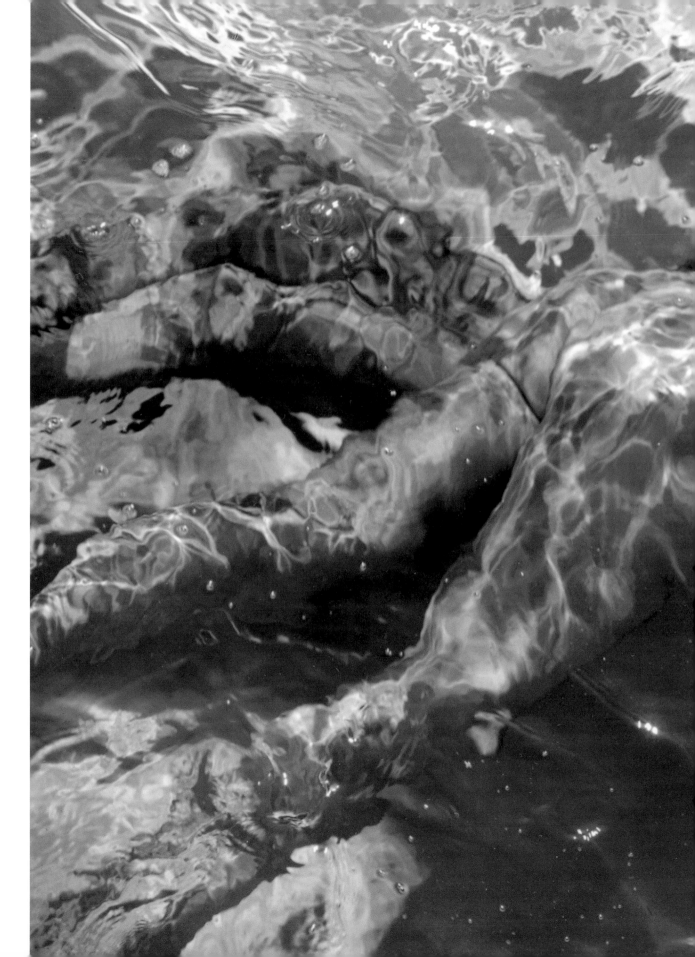

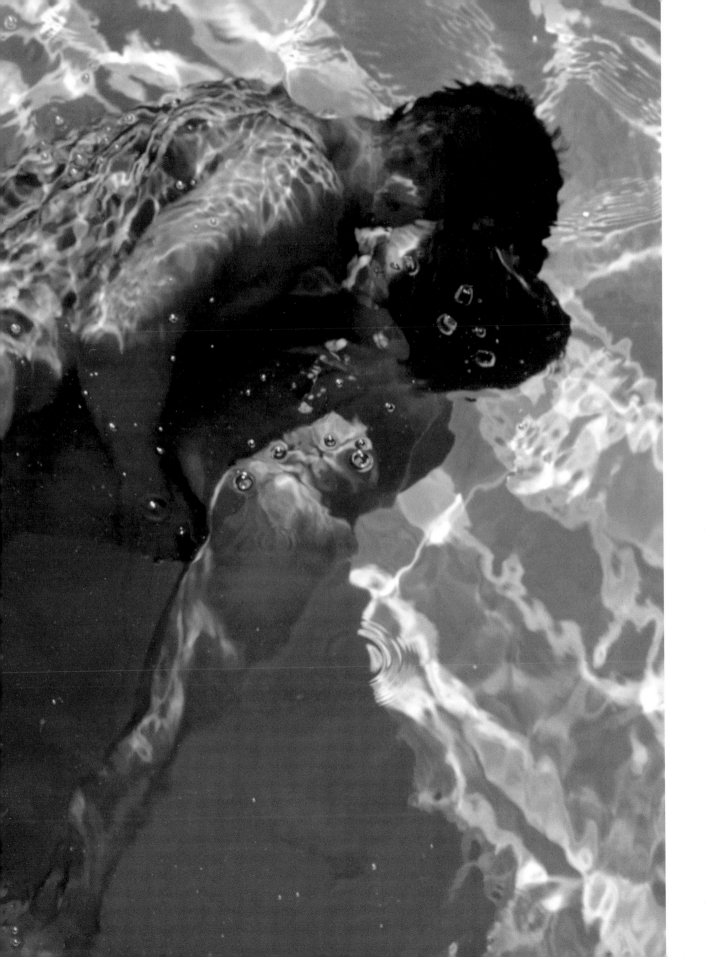

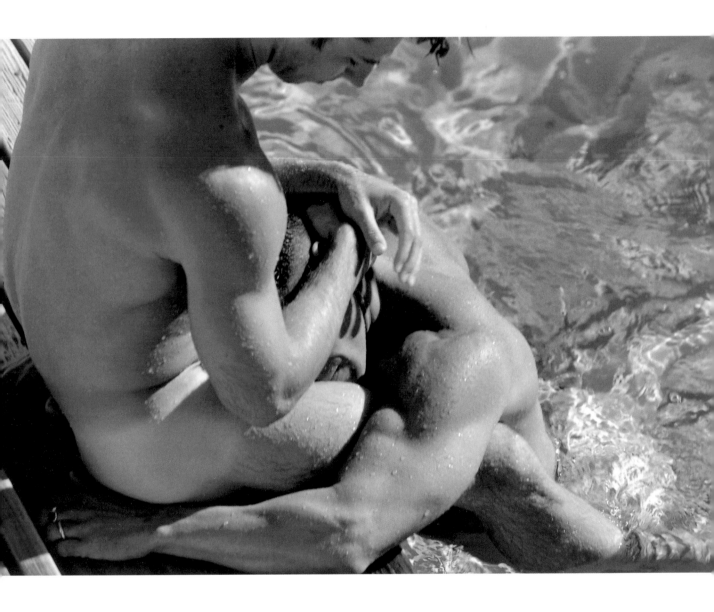

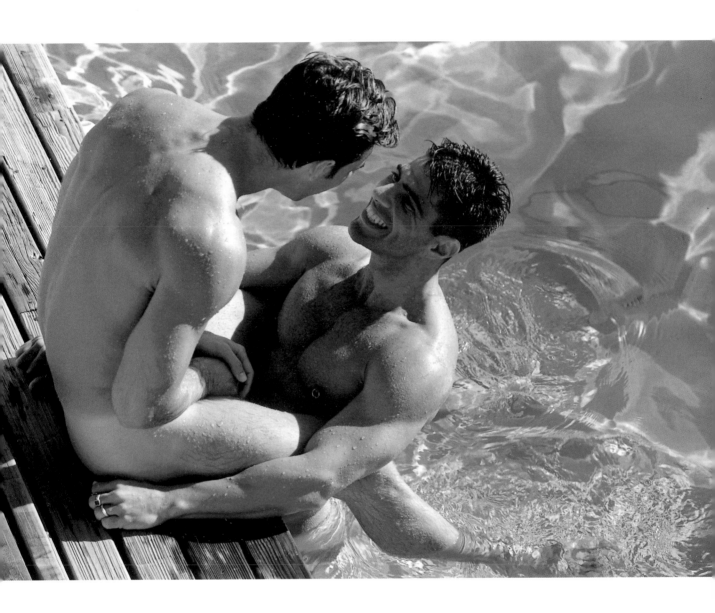

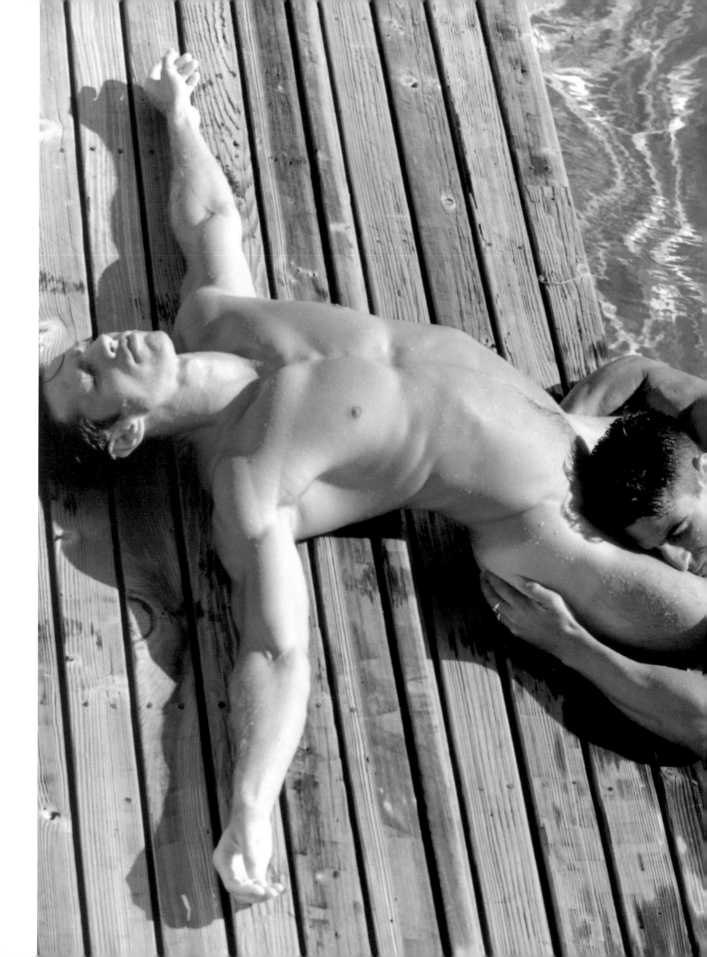

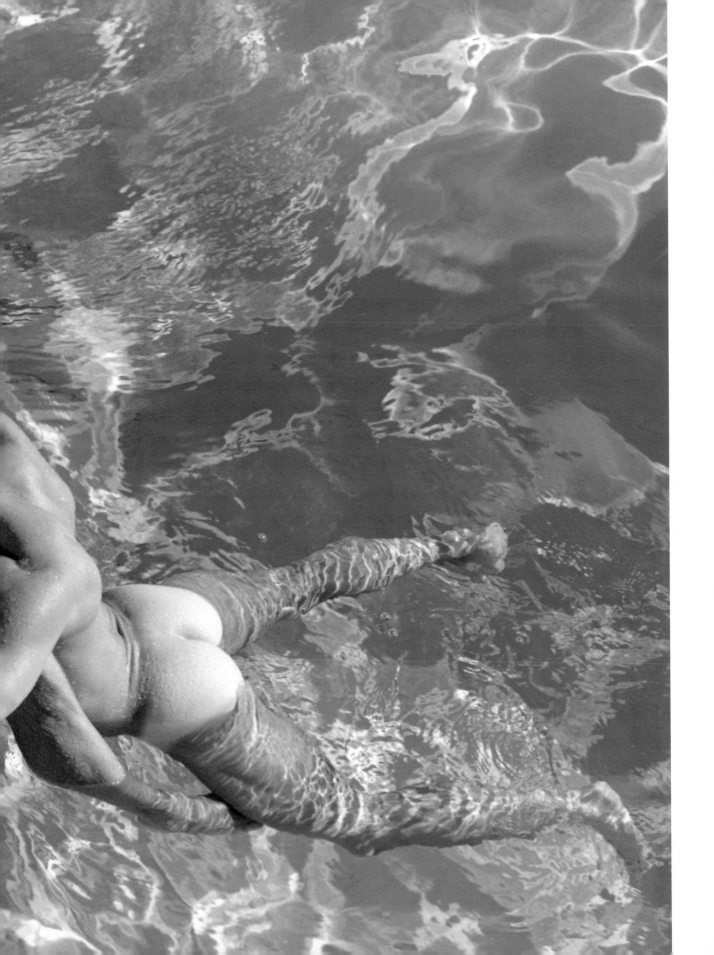

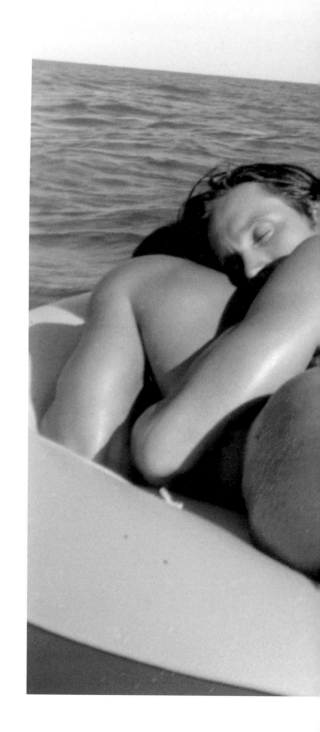

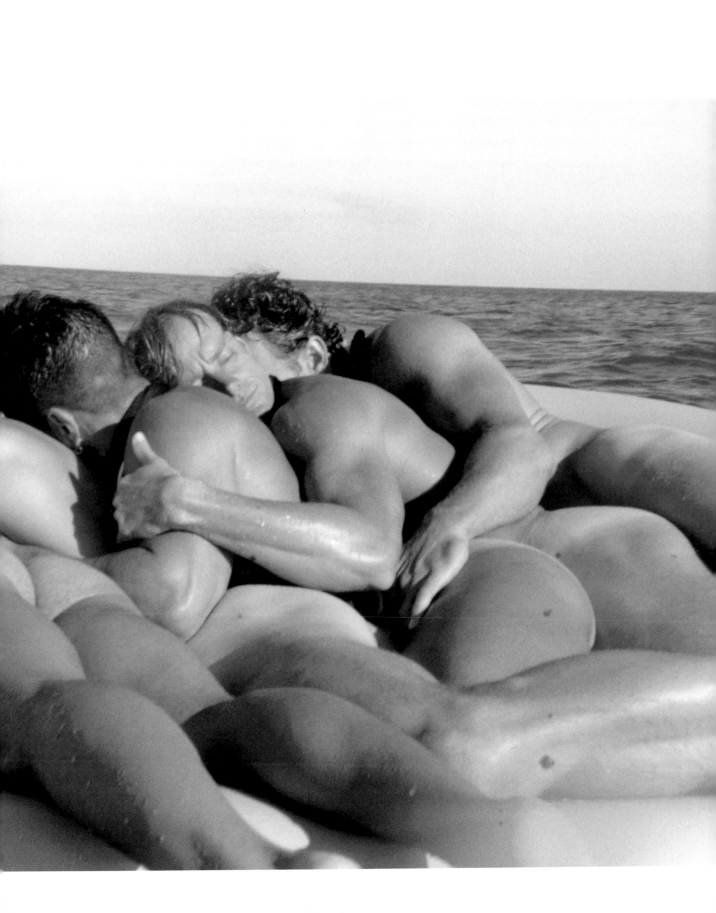

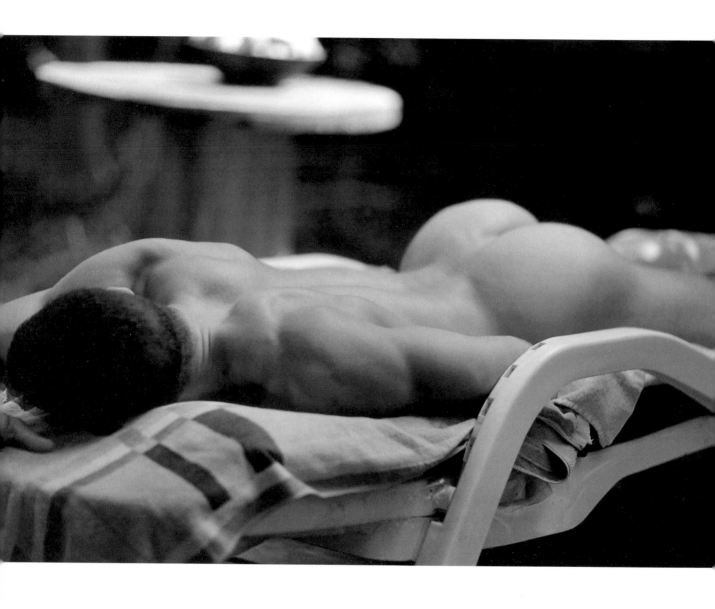

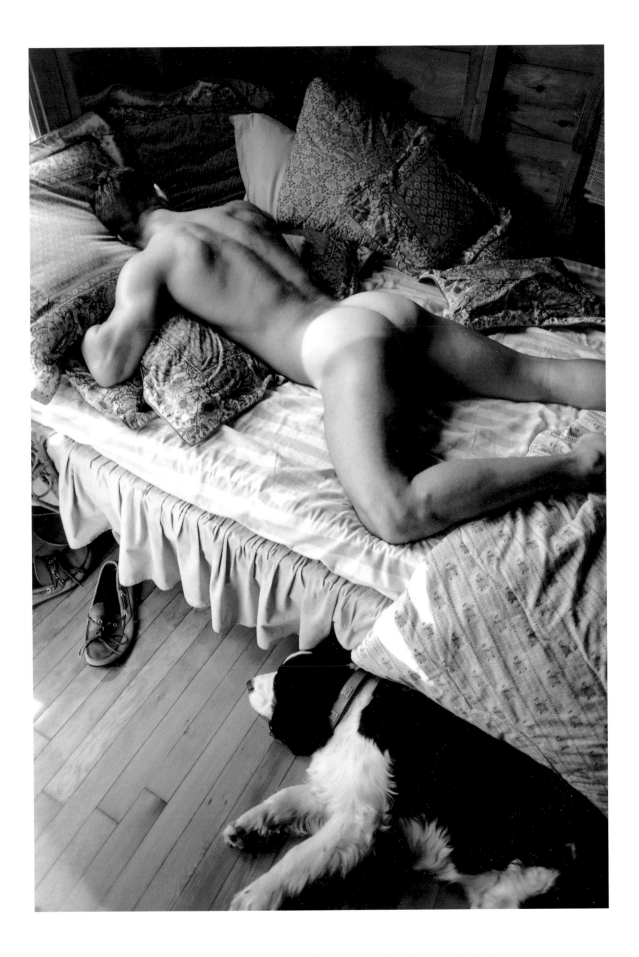

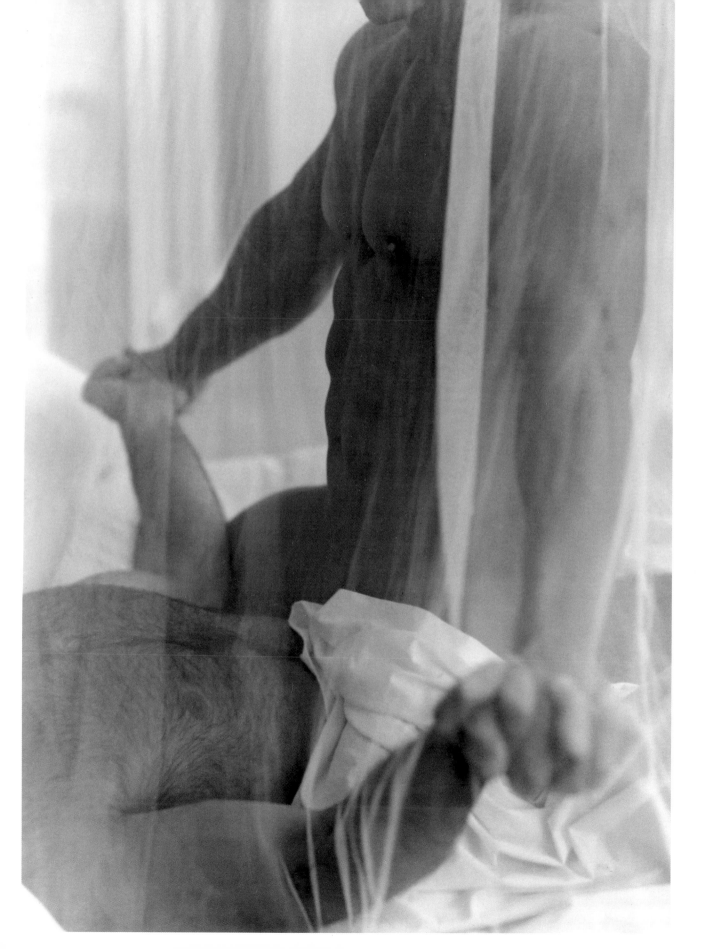

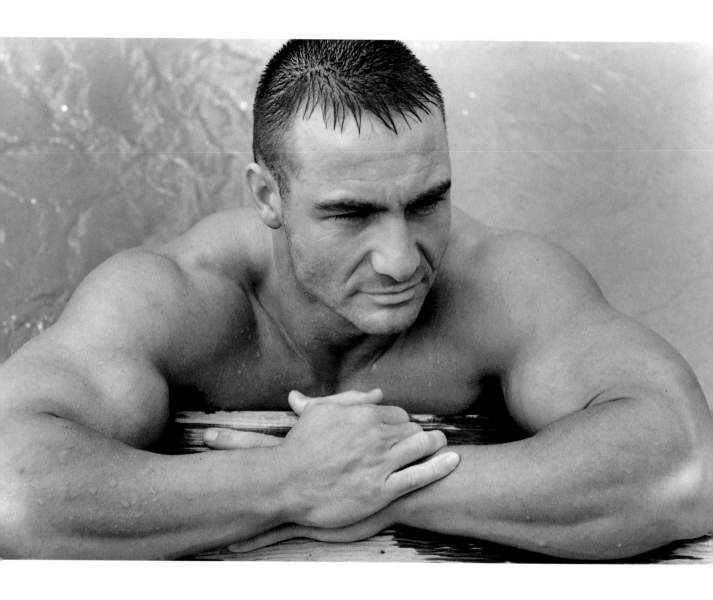

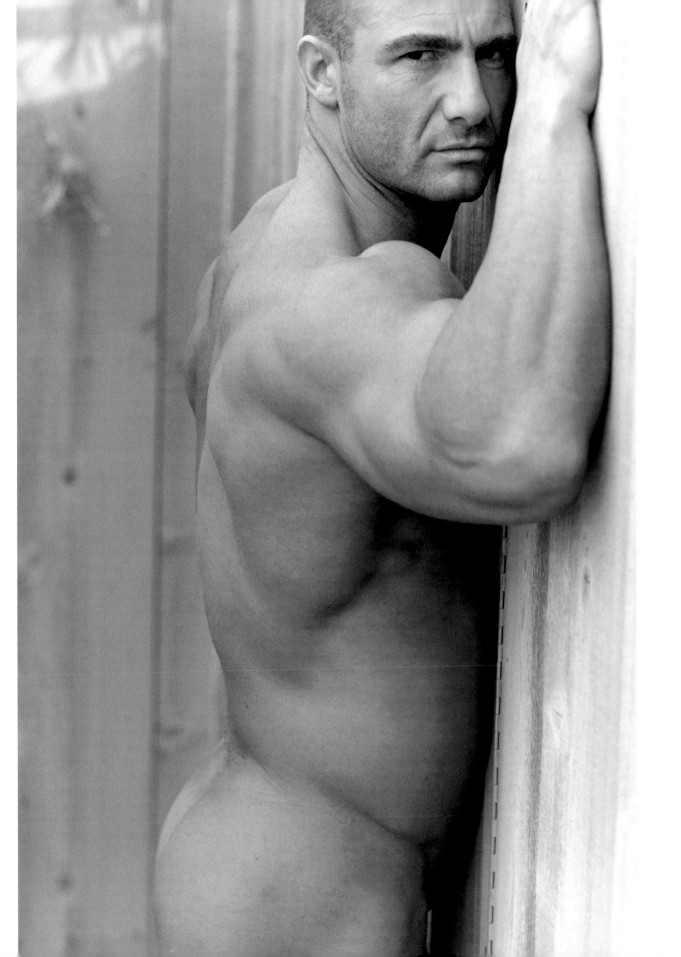

When the sea returns, it tickles their fallen bodies back to life. The naked boy cringes, as if someone were holding a flame too close to his skin. They awake with the rhythm of the water that caresses them at first with its long flirtatious reach, but is soon lashing onto the shore, throwing them around so that he hears their boyish laughter. They approach him again; their wet warm bodies surround him. One of them has gone and returned dragging a full red wagon. They start their games and he cannot stop them; he might as well ask the west wind not to dally with its dark mistress, the sea. They start their games, giggling as if they were still boys, though he knows that like him they have already grown into men, for their thin trunks hold close bundles heavy and inviting and unreachable as the fruit that hangs ripe in paradise. They wrap towels around their heads and don flamboyant oval sunglasses, as if they were old movie stars. Some of them slip out of their trunks and like wicked stepsisters force their big feet into glittery pumps. They climb on each other and fall on each other and continue to perform till they hear a giggle sprout from the naked boy's heart, a giggle that burgeons into a smile and then into a wild garden of laughter.

So they approach him, still in costume, still in character, fairy-tale stepsisters and great divas all. Coquettishly, playful as crabs, they trace circles with their toes around him, till they are all close enough that he can feel their breath on the crown of his head and the sides of his neck, on his brow and his lips, under his arms and the soles of his feet, and he can feel their warmness as if it were the brush of a hundred fingers, and he remembers the restoring warmness of the waters and remembers how much they gave him.

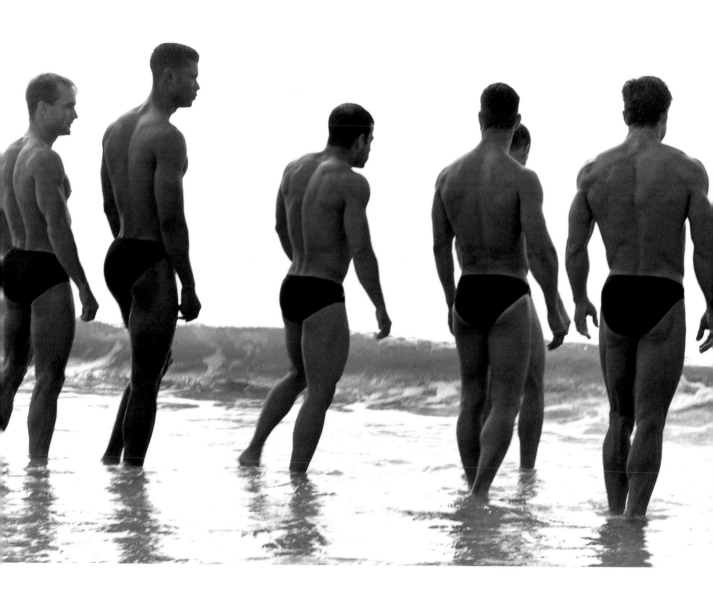

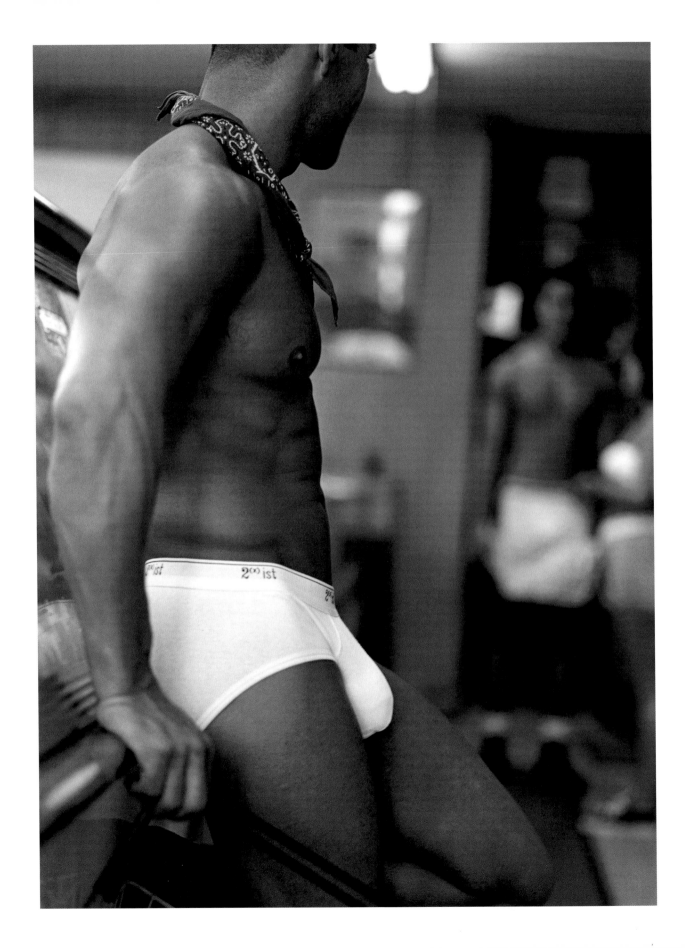

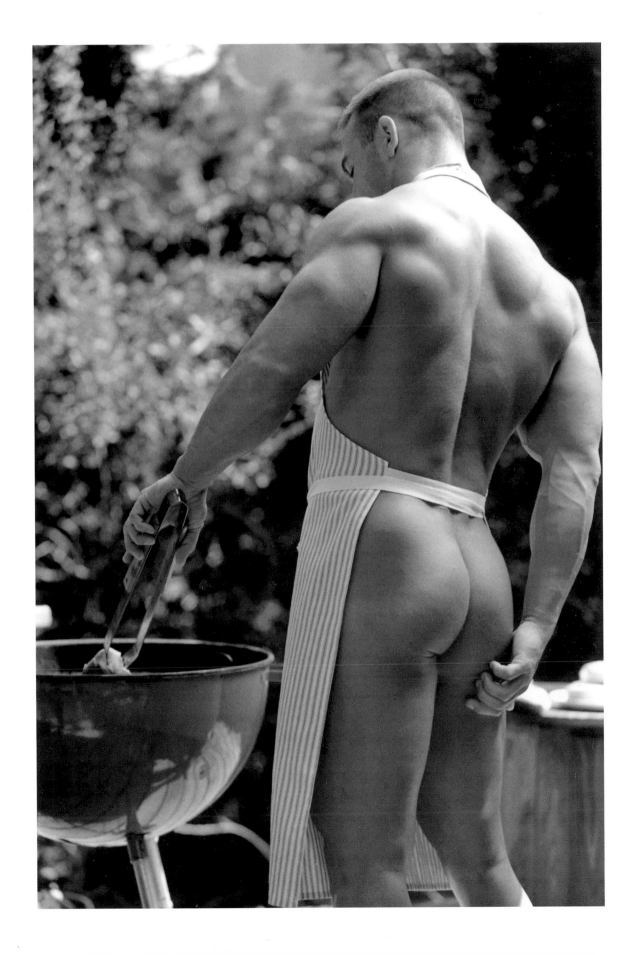

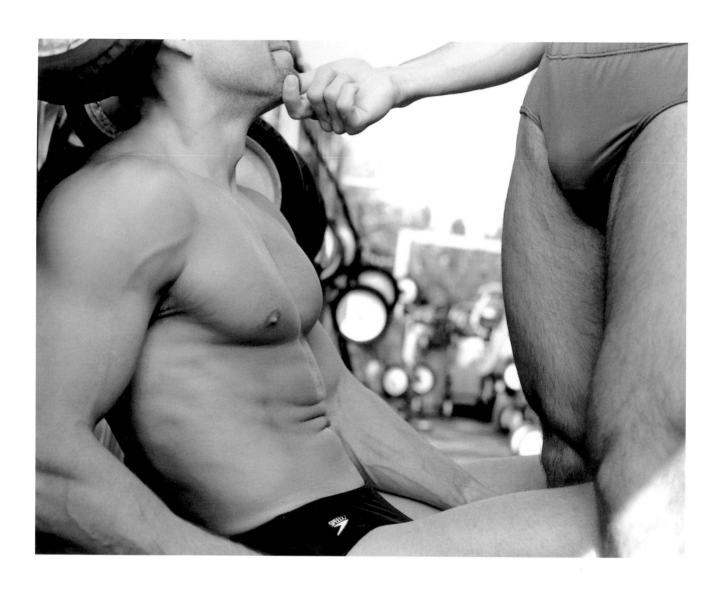

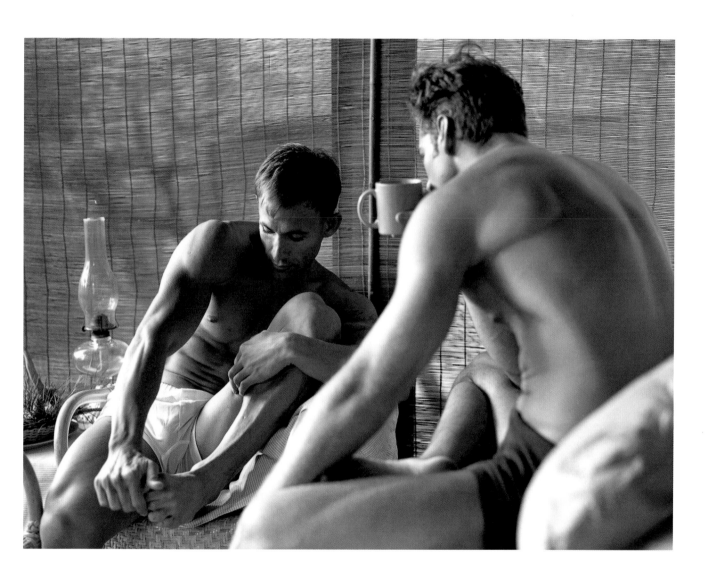

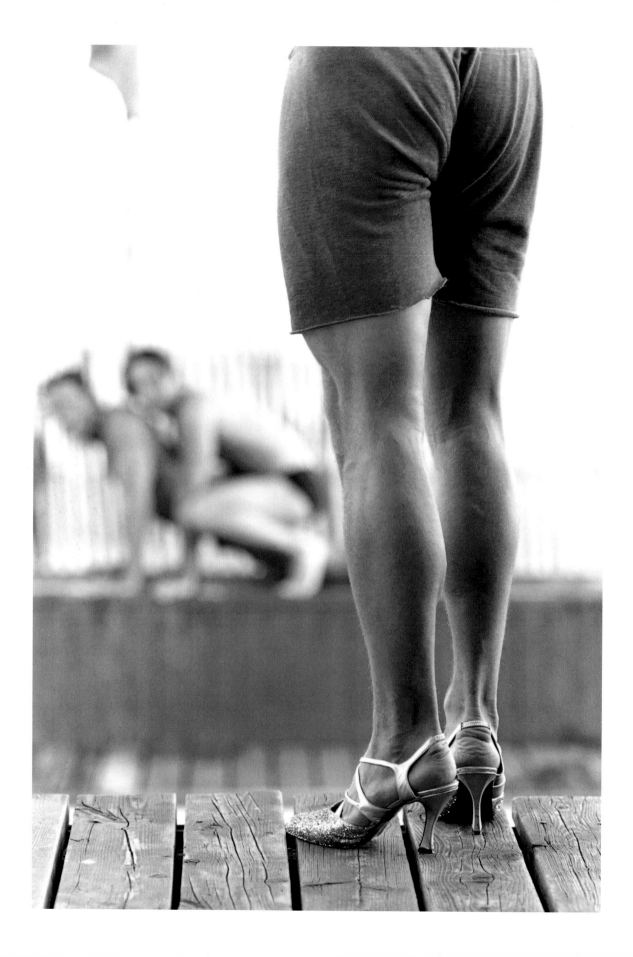

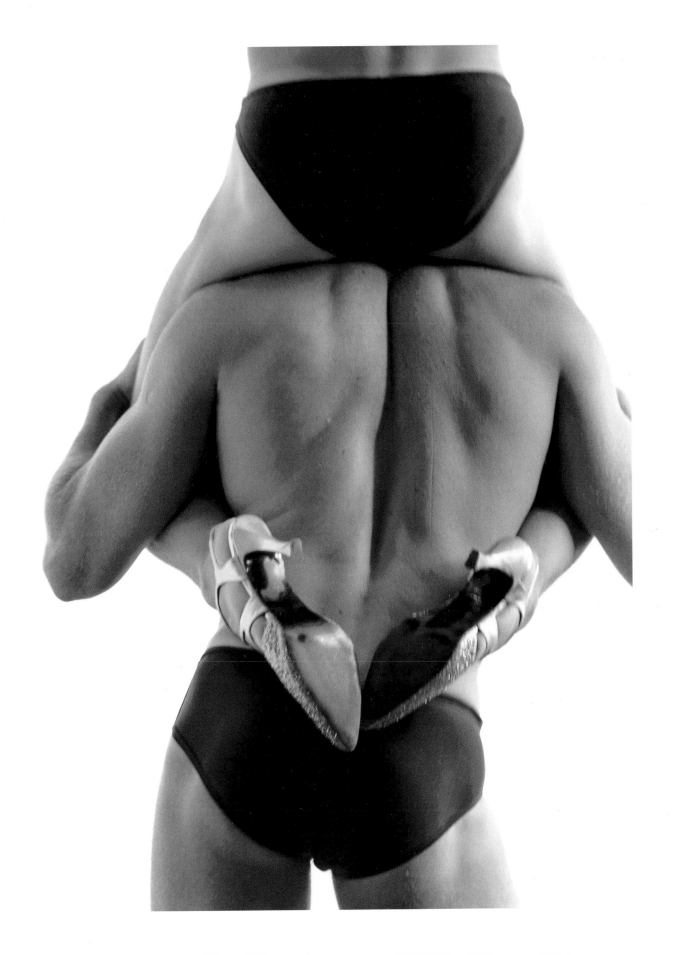

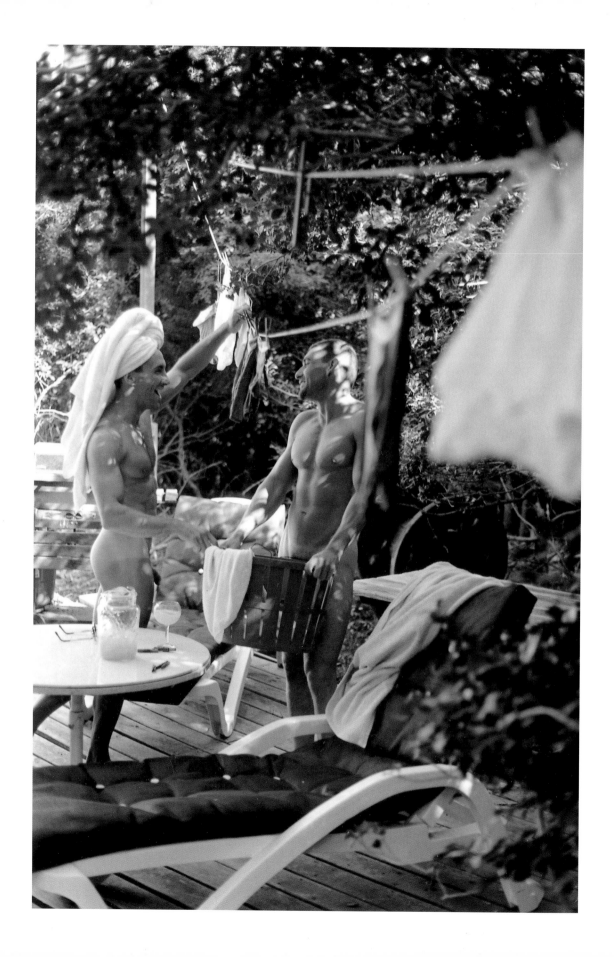

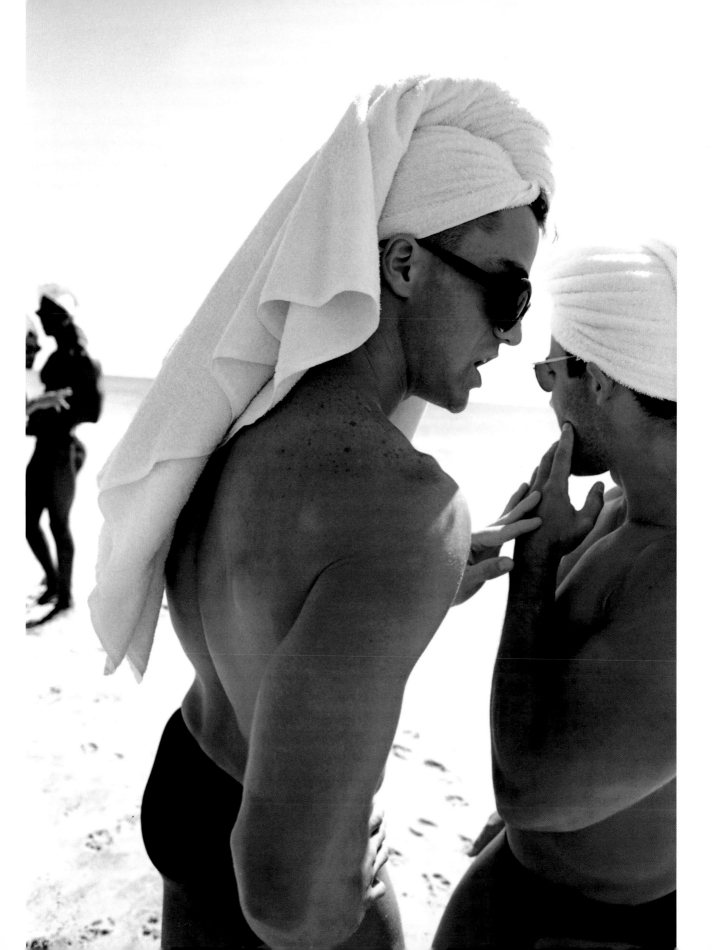

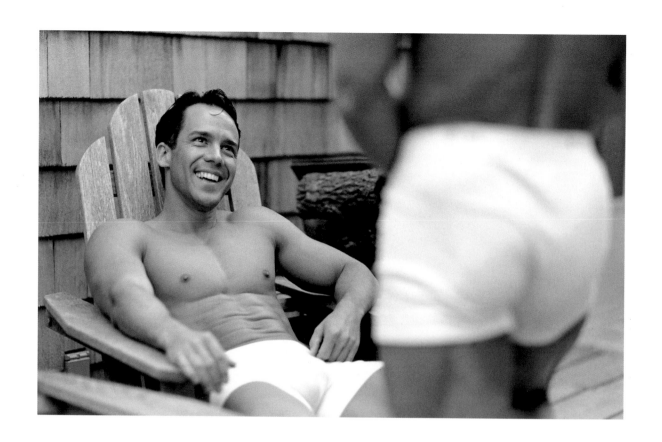

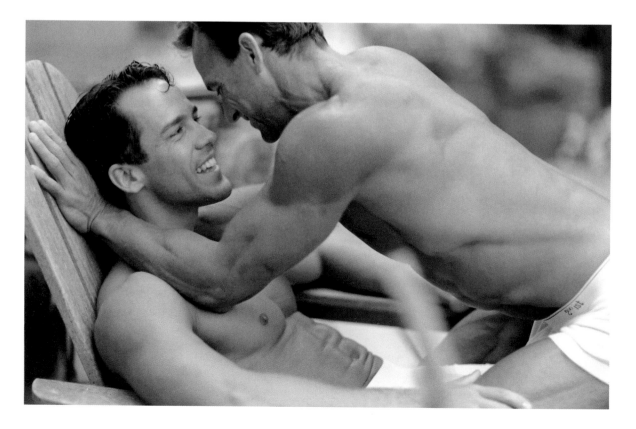

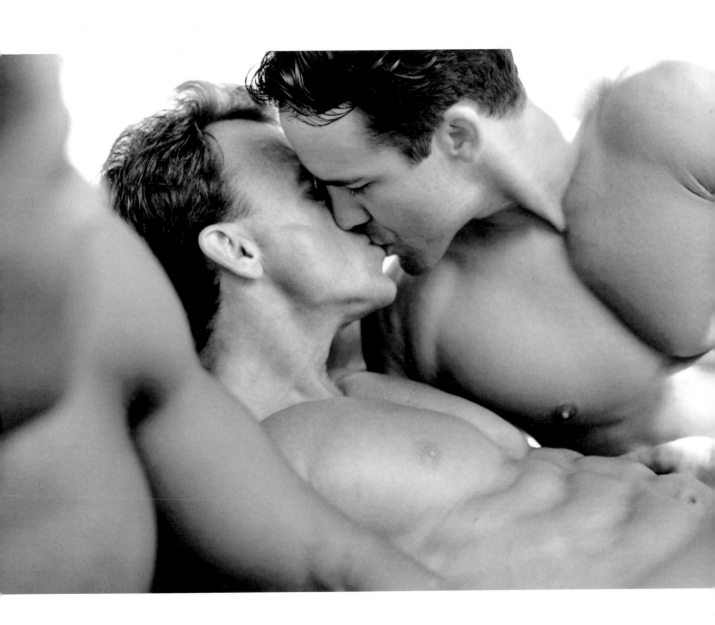

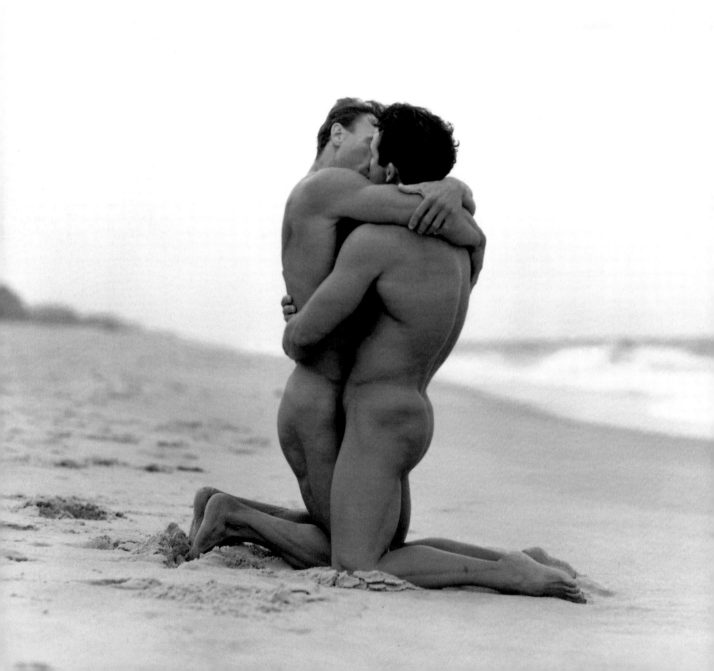

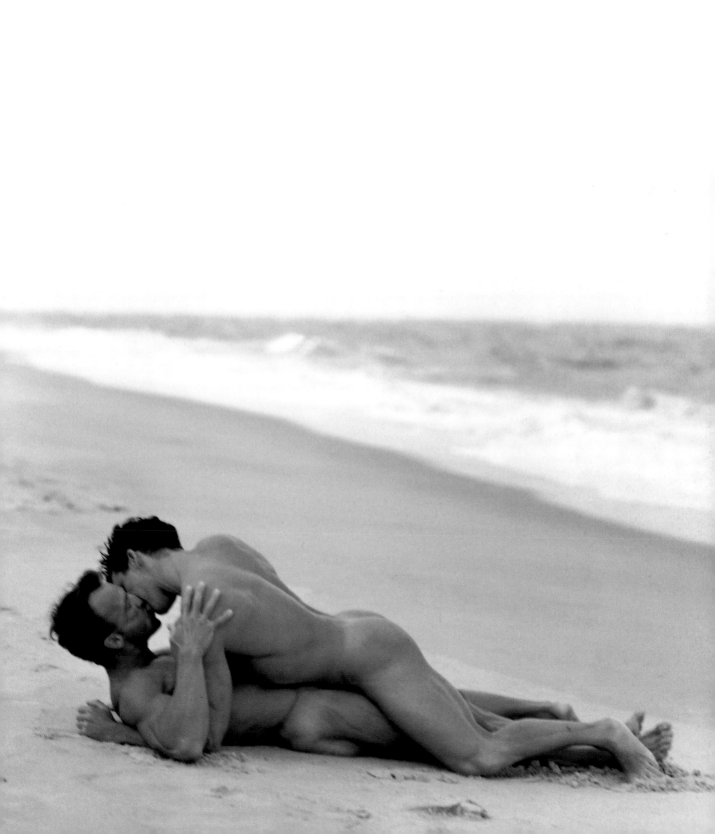

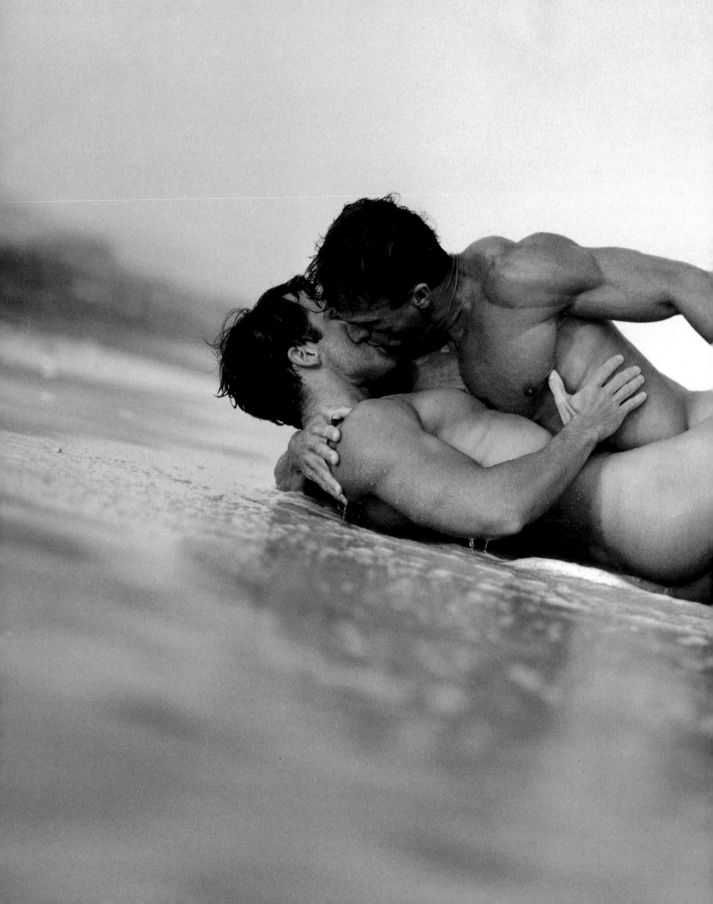

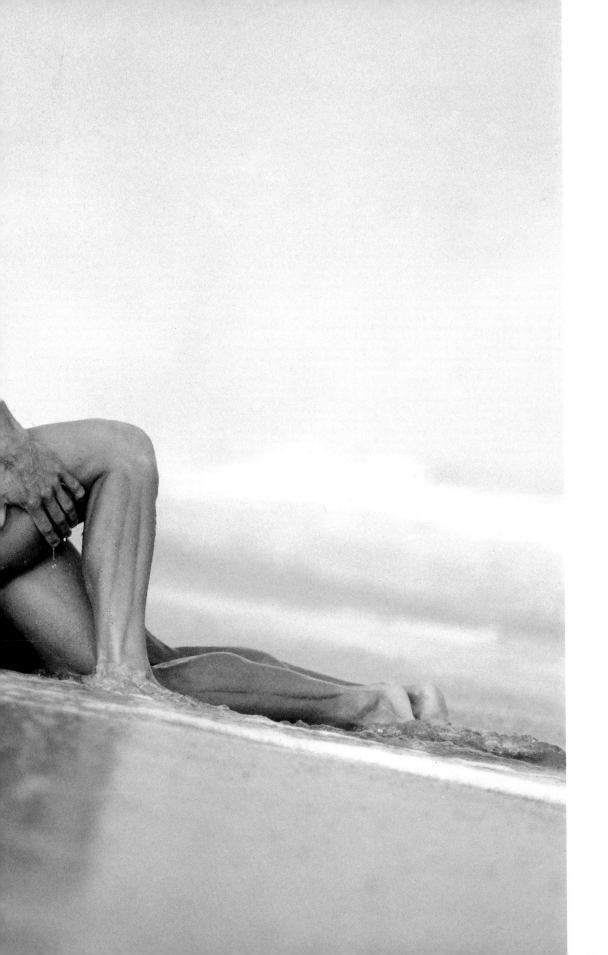

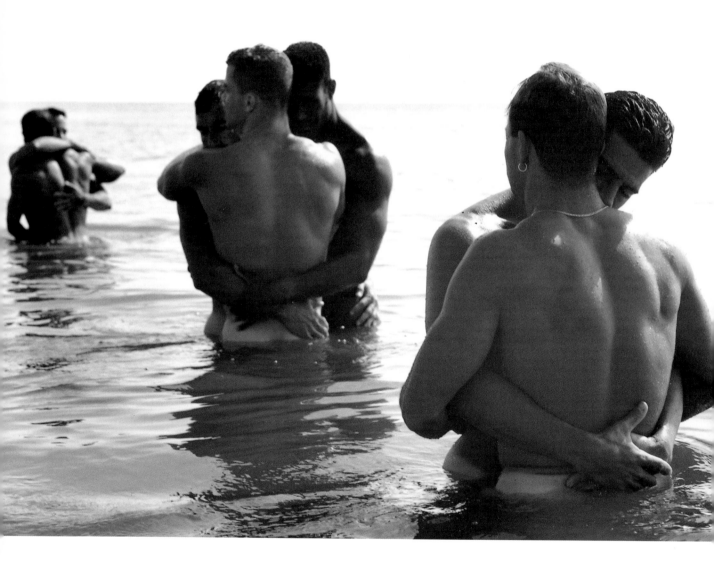

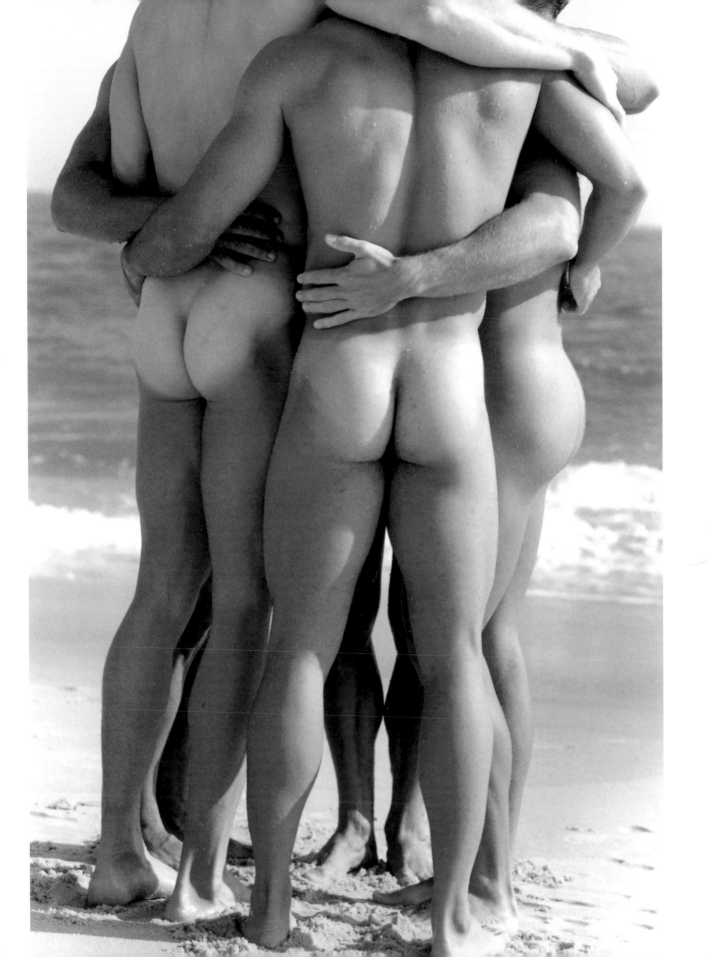

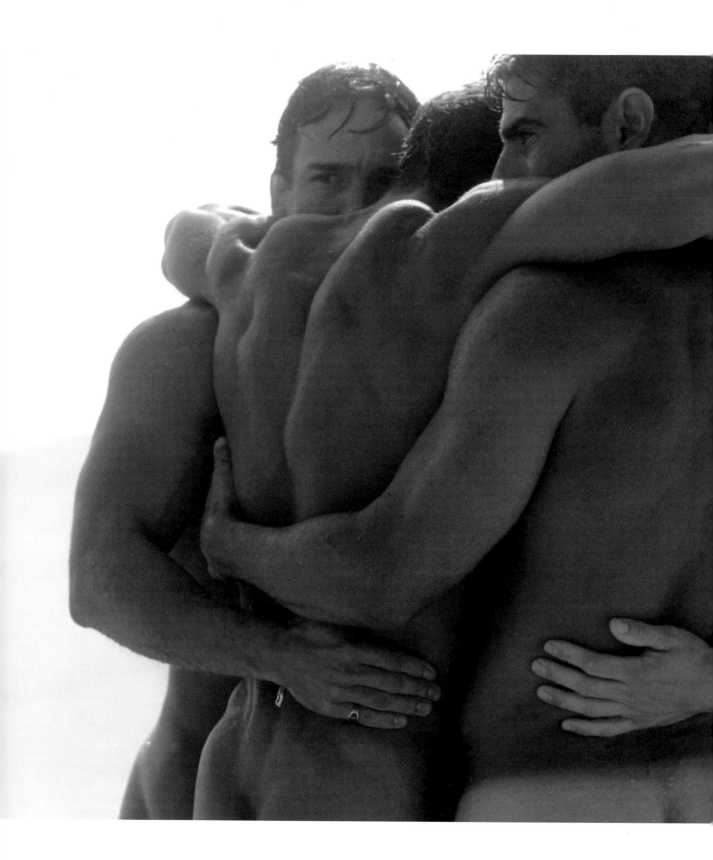

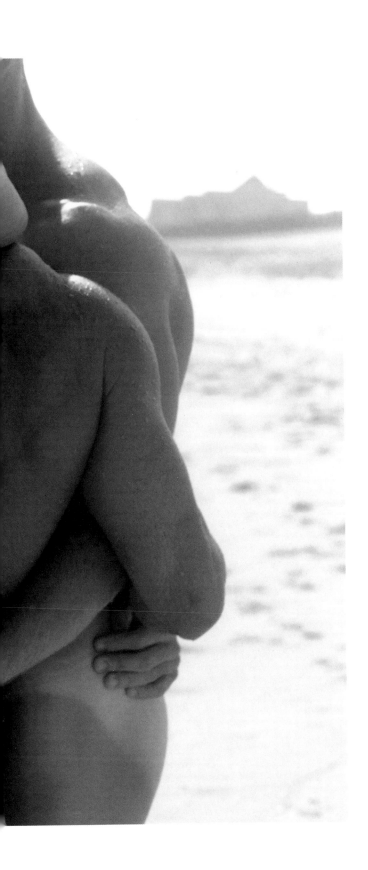

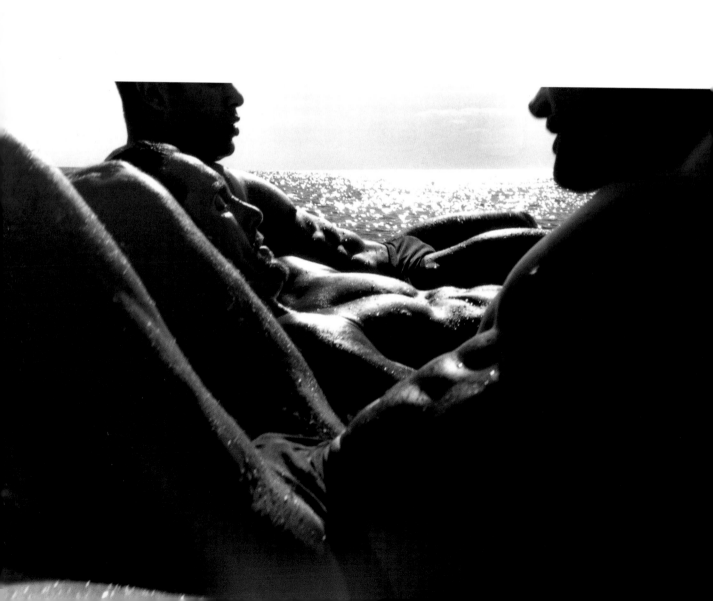

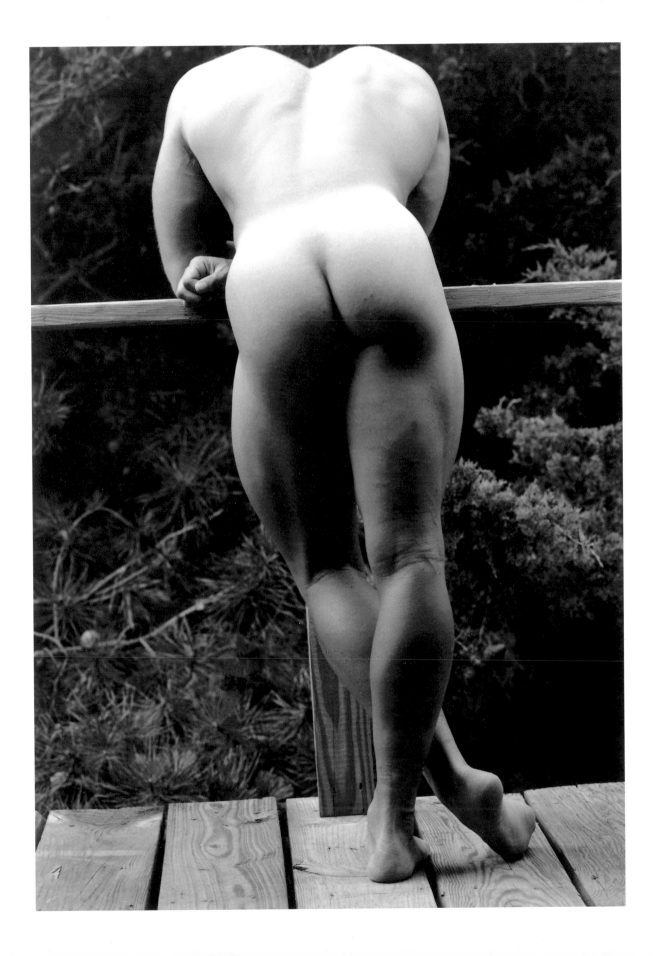

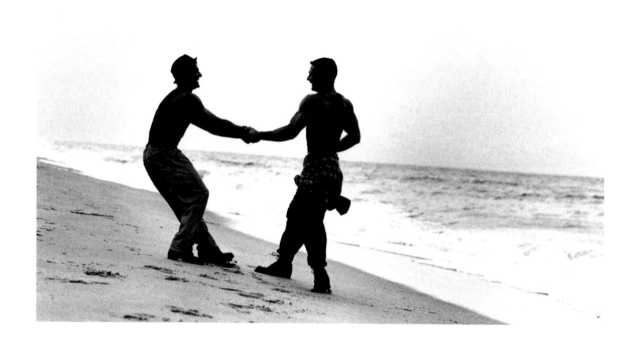

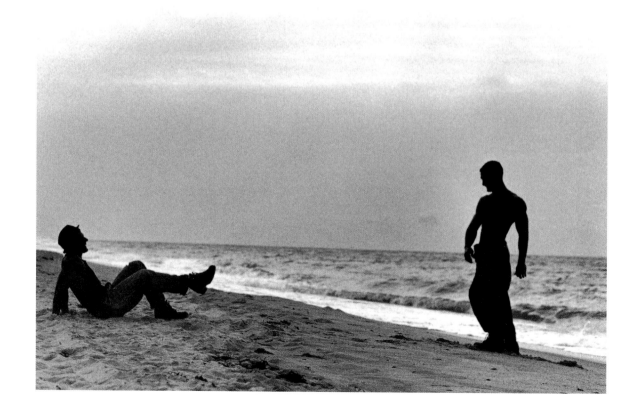

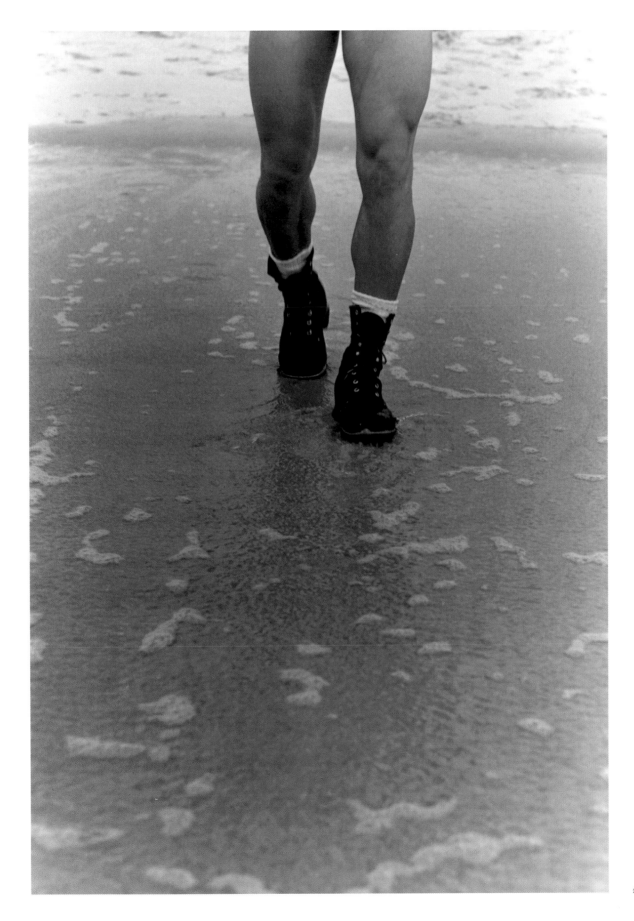

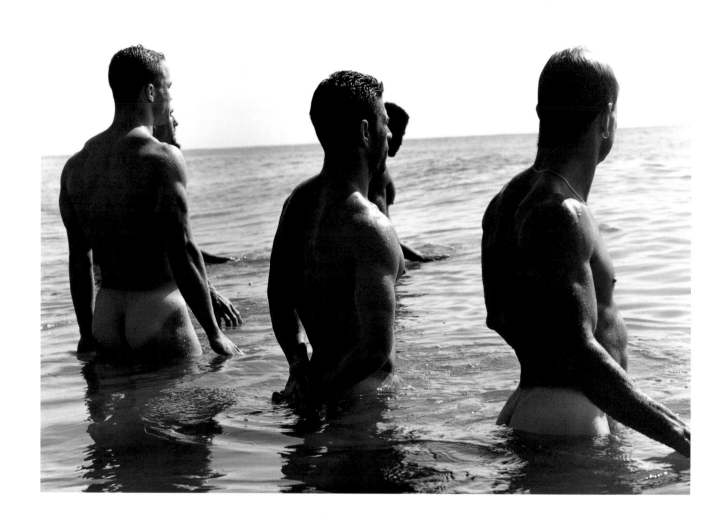

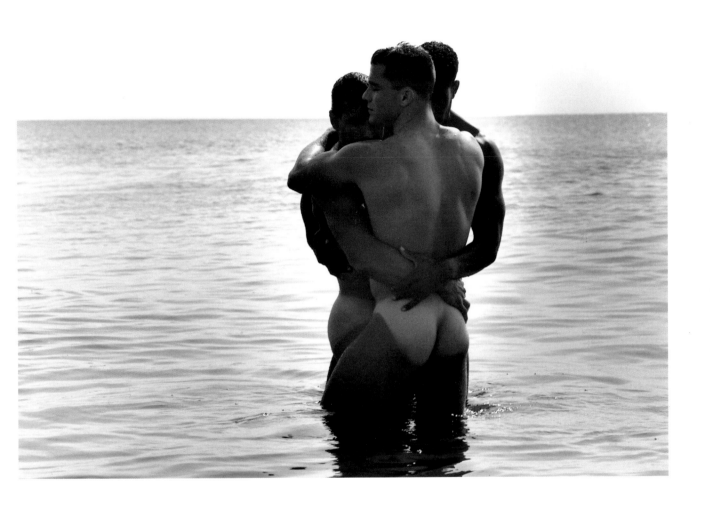

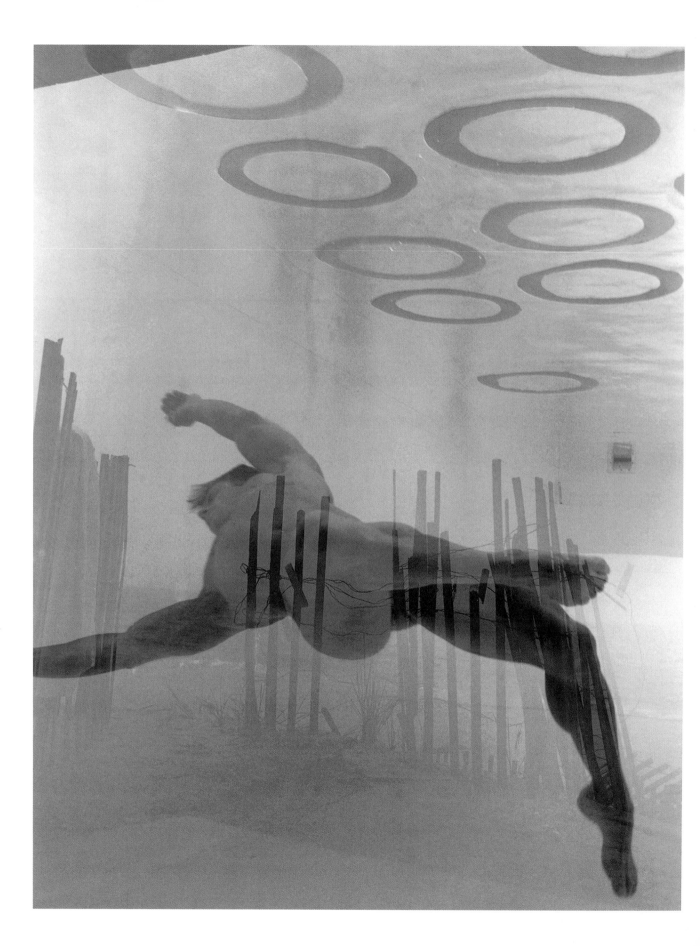

So *he* lets them lead him to the sea, which has shed her dark mantle

and is eagerly returning for him, green as a stripped branch, as hope and

envy. He is carried there by the magic carpet of their soothing breath,

and the sea reaches for his toes and taps at his ankles and spits on his legs

and soon holds him close again and lets the others hold him, for they are

all like him, like the sea herself, naked, giving, full of grace. And a

viscous, mandarin light spills like the life of a sacrifice off the watery table

of the world; and near the shore long shadows mourn its brief and

generous hours.

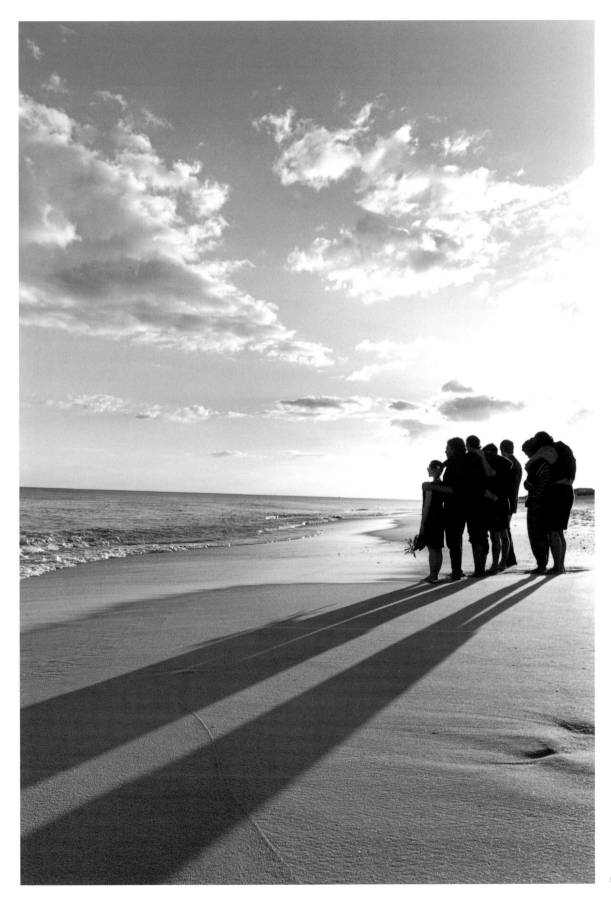

Acknowledgments

Michael Denneny first came to my studio as a subject for a portrait book project by Phillip Sherman. As one of the hundred influential men and women celebrated in *Uncommon Heroes*, he is truly a role model for gay and lesbian Americans. As an editor, he performs his almost impossible dance between art and commerce with a grace that is difficult to describe. But his uncommon care for the authors, artists, and even the book designers who shine in his light is rare in the publishing business. I am grateful for his support and lucky to be under his guidance on this second project with St. Martin's Press.

I am equally grateful that another Denneny discovery, Ernesto Mestre-Reed, has endowed my pictures with his stunning dreamlike story. His graceful prose captures the body of work I created so vividly that the inevitable question will always remain: "Which came first? Ernesto's essay or David's imagery?" Bravo, Ernesto! I am honored by your generous talent. The gifted Gretchen Achilles graciously took time from her newborn to design *Beach*. Her respect for imagery is supreme, and I am privileged to be in her caring hands once again. My literary agent, Ken Roberts, ably baby-sat me during the difficult months of negotiation, serving as an excellent cover for my perfectionist drive. My dear friend Steven Weissman bravely guided me through the early negotiations of *Beach* with grace and keen foresight. His unseen work on the project at its inception was gallant, generous, and perceptive. The beloved Jack Lichtenstein also contributed sage advice during a difficult time. Thank you all.

Houjing Lee, my master printer since 1987, has brought to light every black and white image in this book. His are the second eyes to see my work, and I will always be indebted to his talent, his craft, and his noble devotion to our combined artistic endeavors.

Dallas Boesendahl brought early recognition to my talent and pointed my career in an unexpected new direction in the early nineties. $2^{(x)}$ist designer Gregory Sovell demonstrated enormous faith in my creative gifts soon after. It is no accident that his

garments grace these images, bringing a timeless quality to the publication. The brilliant designer Eddy Trotter, my constant collaborator and best friend, has shared his stunning talent with me almost daily for the past seven years. (He resides in the #1 speed dial on my phone, and with good reason.) I cherish our friendship and our kindred spirits in these visual arts we enjoy.

The creation of this body of work occurred quite suddenly years ago, and those who came together to create these images, the cast and the crew, have patiently waited for the results. My gratitude for their tireless efforts during those ten glorious days cannot be adequately expressed here. Instead, I hope their inclusion in these images will serve as praise enough. Even more, I hope all of you realize how special this experience was for me and how delighted I am that this book has finally arrived in your hands.

Finally, Timothy Reukauf, the remarkable production manager of the location crew, deserves special mention. He was an angel of calm and guided me through the swirling production experience from one end of the island to the other with aplomb. He also styled this book when I wasn't even looking. When a storm blew up, he diffused it with his gentle demeanor. His serene nature had a beguiling effect on my creative process, and I believe these images are somehow imbued with his aura. This book should be his pride as well, for he knows every image dearly.

So many more supportive friends include: Wayne Ballantyne, Edward Bergman, Keith Bernardo, John Blair, Michael Boss, Charles Busch, Amanda Butterbaugh, Tim Cass, Jane Cohen, Nick DeBiase, Doug Dimon, Raymond Dragon, Sandra and Jim Field, Joe Fontecchio, Nicki Foster, Tim Foster, Brad Haan, Dane Hall, Russell Halley, Fred Hochberg, Bob Howard, David Kniazuk, David Lengen, Milton Lubich, David Maderich, Leslie Mandel, Paul Margolin, Luke Martland, Aldona and Joe McCarthy, Jason McCarthy, Rich Morgan, Peter Nickolin, Roberto Novo, Michael Philipson, Todd Riegler, Kevin Roche, Paul Rudnick, Phillip Sherman, Phil Smith, Jorge Vargas, Mary Ann Wish, Phillip Woods, Jeff Woodward

. . . and, of course, Jon Giswold.

Titles of Images

Page	Title

Front Jacket: SPLASH MEN

Back Jacket: HARD BODIES

i. RUNNING MATES

iii. BOYS OF SUMMER

v. LONELY WAGON

vi–vii. FENCED IN

ix. TESTING THE WATERS

x. B.Y.O. BLENDER

1. FOOTSIE

2–3. SUNKISSED

4. BITING THE STICK

5. BRIEF ENCOUNTER

6. BEACH NAP

8. A DOG'S LIFE

9. PICK UP STICK

10. THREE MEN AND A DOG

12–13. BEACHBOY, 1998

14. STEVE DREAMS

17. CHARLIE'S TATTOO

18. JACK

20–21. DALVANNE STRUTS

22. WATER WRESTLERS

24. AT THE BEACH

25. DALVANNE'S CATCH

26–27. SOMETHING BETWEEN THEM

28. TEMPERATURE RISING

29. HOT TUB BUNS

30. HOT TUB BOYS

31. MOUNTING WAVES

32. TOO TOO

33. TWO TOO

34. TATTOO

37. BEHIND GLASS DOORS

38. OUTDOOR SHOWER

39. SHAVING

40. ALL SOAPED UP

41. SEX IN THE SHOWER

42. KISSING FACE

44. JACK'S NAP

46. SUMMER BREEZE

47. THE TOWELETTES

48. ODD MAN OUT

49. EDGAR AND ANTHONY

50. PLAID SHORTS

51. PLAID SHORT?

52. DALVANNE'S TORSO

54–55. RUNNING WATER

56. WET PARTY

57. HARD BODIES

Page　　　*Title*

58–59. DANCE ON THE BAY

60. WORKIN' IT

62. PUBLIC SEX

63. SAND WRESTLE

64. INTO THE WOODS

65. DUNE BUDDIES

66. GOOD 'N' PLENTY

68. RANDY, ANTHONY, AND EDGAR

69. EDGAR

70–71. UNDERWATER

72. POOLSIDE EMBRACE

73. GEORGE SMILES

74–75. SOAKING IN THE SUN

76–77. ADRIFT

78. JACK'S BUNS

79. DOGGY NAP

81. MOSQUITO NET

82. NICK

83. NICK AT THE WALL

85. WADING BY THE SEA

86. SHOPPING BASKET

87. HOT BUNS

88. CORRALLED

89. MORNING COFFEE

90. GETTING PUMPED

91. SUMMER SHOES

92. LAUNDRY TIME

93. BEACH GOSSIP

94. NORM SMILES AT RANDY and RANDY
　　MAKES THE MOVE

95. RANDY AND NORM SMOOCH

96. KNEELING KISS

97. SURFSEX

98–99. BODYSURF

100. ISLANDS AT SEA

101. STANDING HUDDLE

102–103. HUDDLE

104. ABS-A-WAVES

105. A LOOK AT NATURE

106. DANCING AT DAWN and
　　MORE DANCING AT DAWN

107. BOOTS AT THE BEACH

108. LOST AT SEA

109. RANDY'S HUDDLE

110. WATCHING NOAH THROUGH THE
　　WINDOW IN FRED HOCHBERG'S
　　POOL, 1996

113. SUNSET MEMORIAL

118. WALKING THE WAGON

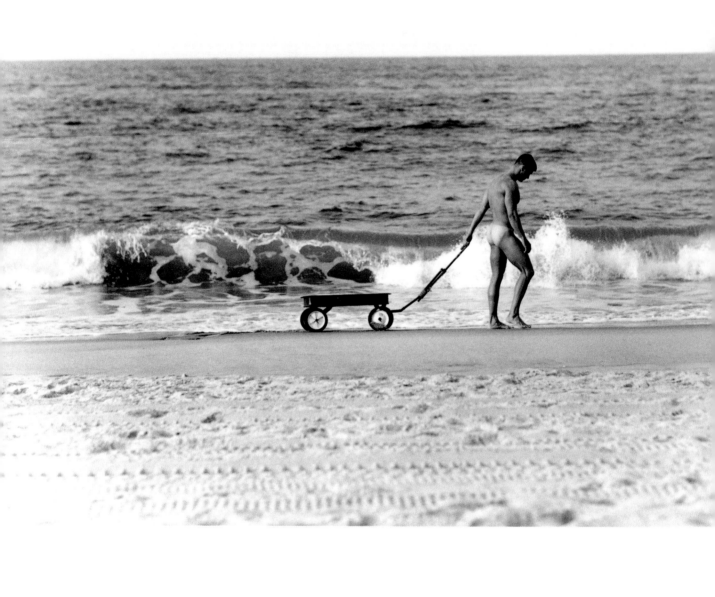

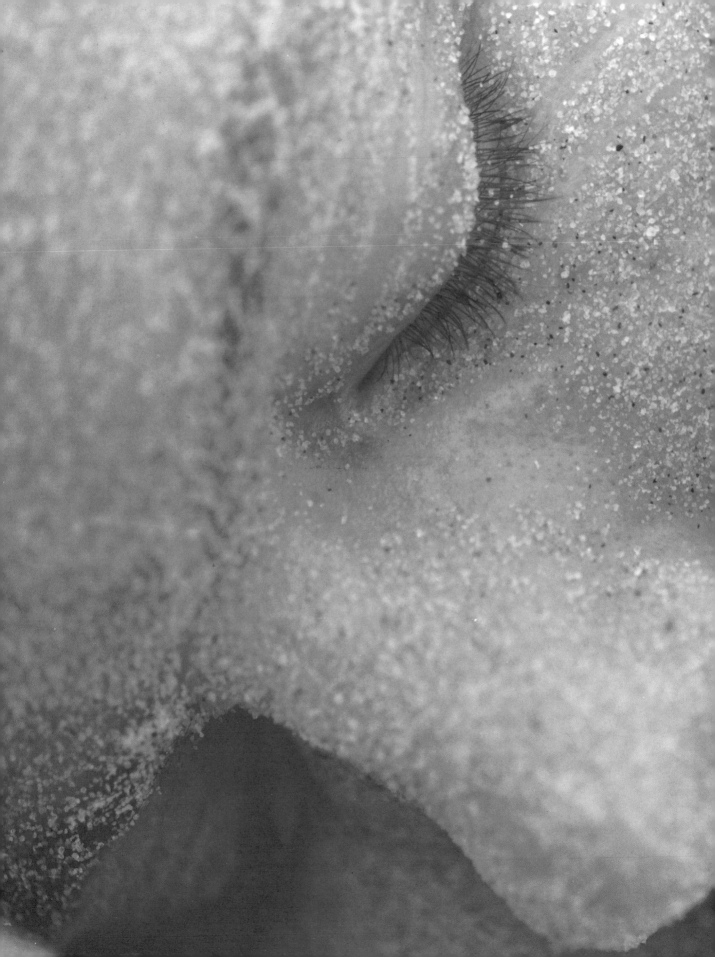